JOHN CLEMMER: EXPLORING THE MEDIUM, 1940-1999

JOHN CLEMMER: EXPLORING THE MEDIUM, 1940-1999

CLEMMER

NEW ORLEANS MUSEUM OF ART, 1999

2,000 copies of this catalogue were published in conjunction with the exhibition *John Clemmer: Exploring the Medium, 1940-1999,* organized by the New Orleans Museum of Art.

Exhibition Curators: David Clemmer, Leo Costello, and Gridley McKim-Smith

Exhibition Itinerary:
New Orleans Museum of Art
 October 2–November 21, 1999
Alexandria Museum of Art
 Alexandria, Louisiana
 April 1–May 28, 2000
Meadows Museum of Art, Centenary College
 Shreveport, Louisiana
 June 10–August 13, 2000

Library of Congress Catalog Card Number: 99-74618
ISBN 0-89494-076-7

Photography: All plates by Judith Cooper, New Orleans
 Museum of Art, except:
Plate 22 – Xystus Studio, Springfield, VA
Plate 29 – Tom Neff, Baton Rouge, LA
Plate 44 – Twin Palms Studio, Tallahassee, FL
Plate 55 – Dan Morse, Firefly Studios, Santa Fe, NM
Pages 19, 30, 106, 112 – Kurt Knoke, Gresham, WI
Pages 11, 20, 111 (lower right) – Harold Trapido

Catalogue Design: Maria Hwang-Levy, Swell Design,
 Santa Fe, New Mexico

Printing: Palace Press International, Korea

Cover: *Topographia IV–Cosmas II,* 1970 (cat. no. 25)
Page 7: John Clemmer with model, Wright Field, Dayton,
 OH, circa 1945.
Page 11: John Clemmer in front of *Homage to Paul,*
 Foucher Street studio, circa 1964.
Page 20: John Clemmer working on *Topographia V–*
 Capricorn in Foucher Street studio, circa 1973.
Page 30: John Clemmer in Sheboygan, WI, studio, 1997.
Page 107: John Clemmer in Sheboygan, WI, studio, 1997.

Contents

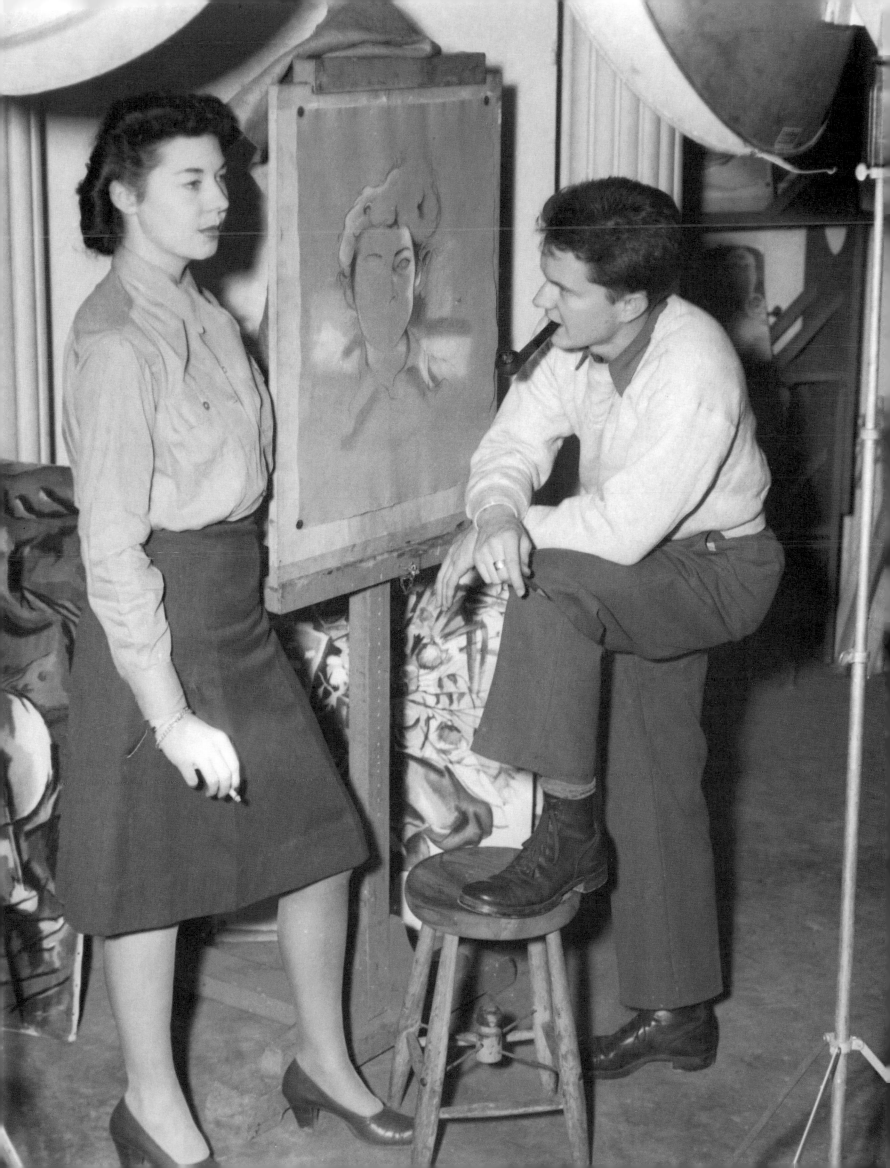

Preface and Acknowledgements

For over half of the twentieth century, John Clemmer has been a steadfast and enduring presence in the cultural life of New Orleans. Born in the bayou country in 1921 to a Wisconsin native father and the daughter of a prominent French family, he attended New Orleans public schools and received his first (and only) formal art training at the New Orleans Art School. From the late 1930s through the mid-1950s, Clemmer was both an observer of, and an active participant in, the vibrant and colorful French Quarter scene. He was present at the very beginnings of the modern art movement in the city, and he remains an essential part of it to this day.

In 1946, following military service, he became the director of the Arts and Crafts Club, the first New Orleans gallery to exhibit progressive contemporary art, and also began his teaching career in the associated Art School. Five years later, his professional path led to the Tulane University School of Architecture and the Art Department at Newcomb College, where he taught drawing, painting, and design. In a pre-computer age, he introduced generations of architecture students to the tools of their trade.

Clemmer held a full-time academic appointment at Tulane University for more than three decades, culminating in his assuming the Chair of the Newcomb Art Department in 1978. Throughout his years with Tulane he continued to pursue his art, producing a compelling and diverse body of work. In addition to large numbers of paintings and drawings, Clemmer's concern with architectural design gave rise to sculptural investigations in a variety of media. Included in this exhibition is an overview of his three-dimensional work, presented in a video produced especially for the occasion.

Although portraiture and floral subjects recur throughout the decades, it is the landscape which remains a constant in Clemmer's oeuvre. Travels to foreign lands (Colombia in 1962; Greece and Turkey in 1968; Italy and Greece in the 1970s, 1980s, and 1990s) have resulted in some of Clemmer's most inspired work. Closer to home, the bayou country of Louisiana and the rural environs of the Clemmer summer home in Wisconsin have been prominent subjects in recent years.

One aspect of Clemmer's career that is particularly striking is the degree to which he has resolutely resisted categorization—whether self-imposed or by the design of others. Although thought of by many primarily as a painter, he has produced a significant body of sculptural work. While the bulk of his output may indeed be easel painting, he has executed a considerable number of large-scale public works. Depending on what period of his career one examines, he may appear to be either predominantly an abstract or a representational artist.

Simply put, John Clemmer is an artist: fads, fashions, the rise and fall of one "ism" or another, and declarations of post-this or neo-that do not concern him. What this retrospective reveals is the restless and perpetually inquisitive spirit of an artist who has never lost his fascination with the possibilities of the world, or the opportunity for expressing those possibilities in his work. Clemmer's friend Mark Rothko once stated his belief that the most important tool of the artist is "faith in his ability to produce miracles when they are needed." It is my belief that John Clemmer has undeniably produced his own fair share.

The combined efforts of many talented individuals were required to make this exhibition and its associated projects, including this catalogue, a reality. Professor Gridley McKim-Smith and co-author Leo Costello, MA, both of the Department of

History of Art, Bryn Mawr College, contributed an informed and insightful analysis of John Clemmer's work to the catalogue. David Clemmer—writer, art critic, and the artist's youngest son, based in Santa Fe, New Mexico—brought his unique perspective to a thoughtful essay on the artist's life. The catalogue was expertly and artfully designed by Maria Levy of Swell Design, also in Santa Fe. Quality photography is essential to any undertaking such as this, and NOMA's staff photographer Judy Cooper rose to the occasion admirably. The catalogue project was coordinated for NOMA by our Publications Director, Wanda O'Shello. Thanks go as well to NOMA's Registrar, Paul Tarver, whose efforts are always greatly appreciated. The video document of John Clemmer's sculptural work was photographed, directed, and edited by David Nicholson of Muse-Ed of Santa Fe, with the assistance of Katie Peters. Sections of the musical soundtrack for the video were graciously provided by the artist's friend and colleague Milton Scheuermann and New Orleans Musica da Camera. For permission to use excerpts from Paul Paray's *Symphony No. 1* we are indebted to Maestro James Paul (also a close Clemmer family friend) and J. Tamblyn Henderson Jr. of Reference Recordings. The video was a gift to the artist from his wife, Dottie. John Clemmer's work has been introduced to the digital age through the efforts of Jonathan Clemmer—the artist's elder son—and website designer Benjamin Fineman, both of New York City. Frank A. Organo, the artist's studio assistant, was an invaluable asset to the preparations for this show.

The participation of Dottie Clemmer was crucial to this project from the beginning, and I particularly wish to thank her for coordinating loans to the exhibition from private collections and organizing the artist's archives. Of course, our thanks go as well to those individuals and institutions that most generously agreed to loan their paintings and sculpture to this exhibition. Lastly, but most importantly, I extend my gratitude to John Clemmer for his extraordinary fifty-plus-year contribution to the cultural life of New Orleans.

E. JOHN BULLARD
The Montine McDaniel Freeman Director

Lenders to the Exhibition

Gary and William A. Baker

Rick and Martha Barnett

BlueCross and BlueShield of Louisiana

Florence and John Boogaerts

Mr. and Mrs. Charles Bowen

Mr. and Mrs. Victor Bruno

David Clemmer

Jonathan Clemmer

Mari Newman Colie and Stuart Colie

Lin Emery and Shirley Braselman

Honorable and Mrs. Martin L. C. Feldman

Julian and Peggy Good

Dr. and Mrs. Harry Greenberg

Herbert Halpern and Jacqueline Bishop

Burton Jablin

Dr. and Mrs. Eamon Kelly

Dr. Joseph D. Kirn

Mrs. F. Monroe Labouisse Jr.

Edwin Lupberger

Bobby and Karen Major

Mrs. Edmund McIlhenny

New Orleans Museum of Art

Maestro James Paul

Gerald Peters Gallery

Mr. and Mrs. William A. Porteous

Lloyd N. Shields

Dr. and Mrs. Charles C. Smith III

Margery and Charles Stich

School of Architecture, Tulane University

Beverly and Lester Wainer

Two Private Collections

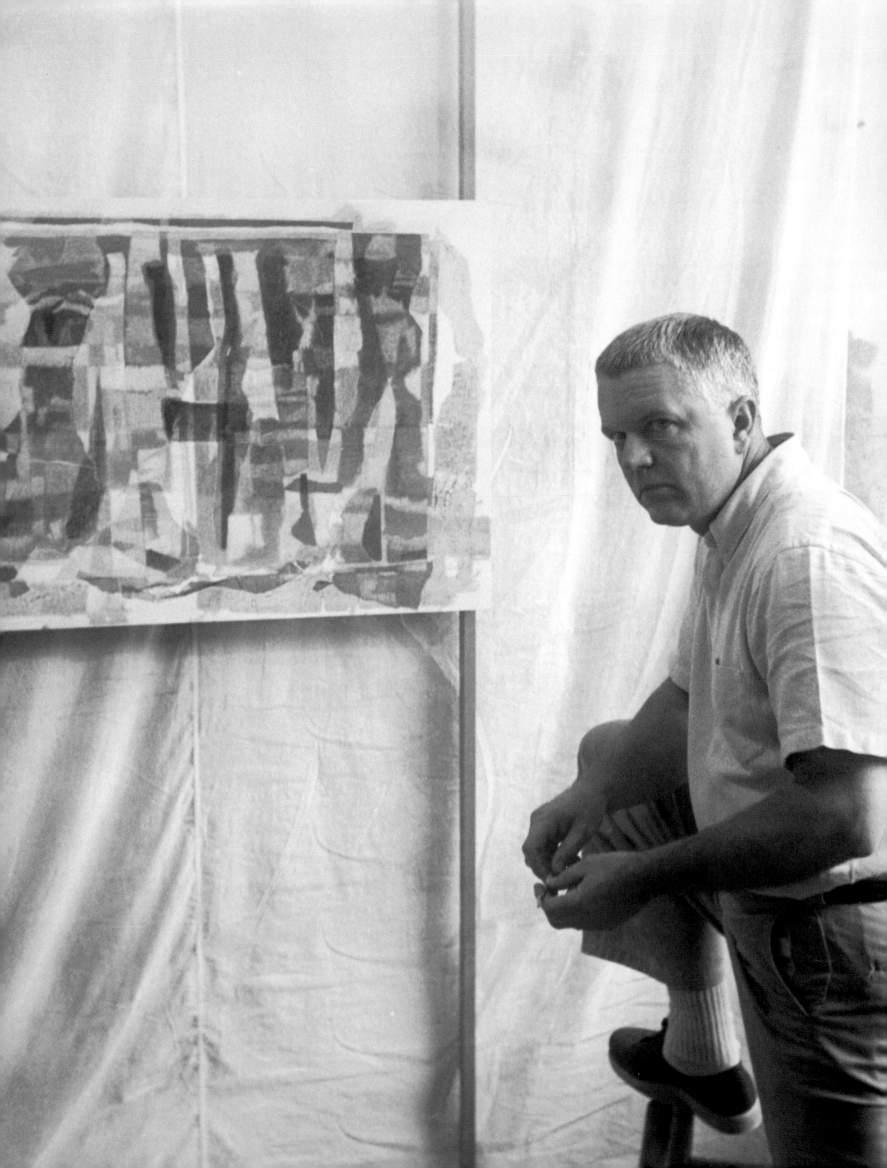

Since achieving a state of alleged adulthood, I have had occasion to reflect upon the notion that growing

BY DAVID
CLEMMER

up in the household of an artist presents a child with a certain skewed perspective on life. As childhood perspectives go, it may be no more skewed from the norm than the version of life experienced by the offspring of lawyers or Lucky Dog vendors or bank robbers, but I have come to believe it engenders a distinctly unique outlook nonetheless.

While growing up, I was always aware of my father as an artist, but I cannot recall ever harboring the impression that there was anything particularly singular or noteworthy about it. It was simply something that he did, and his artwork was just one aspect of the contents of our house. I knew that other people's fathers spent their free time playing tennis or golf, working on cars, socializing in clubs, drinking beer in bars, or simply staring into the flickering blue light of what my parents unfailingly referred to as the "idiot box." My own father spent countless hours alone in a succession of immaculate studios, sitting at his work table, scratching away on Strathmore paper with a Rapidograph pen, or standing in front of a canvas, brush in hand, classical music turned up loud on the stereo. I could never imagine having a father who did any of those other things.

I suppose I realized that our family didn't much resemble the ones on television, but to me *they* were the oddballs — ciphers from some Middle American crypto-suburban fantasyland. Whether such a place truly existed I was not sure, but I knew for a certainty that it was nowhere in the vicinity of our Irish Channel neighborhood. In a way, the whole phenomenon of growing up in New Orleans engenders its own skewed version of reality, for New Orleans was, is, and hopefully always will be a genuinely different kind of place. Having spent all of my first twenty years in the city, the possibility that the rest of the world didn't function with the same set of values and assumptions had never really occurred to me. I recall being incredulous when a friend who had temporarily relocated to the West Coast informed me that in California the bars closed at 1:30 a.m. and you couldn't take your drink with you when you walked out the door.

With all the indignation befitting a sixteen-year-old New Orleans barfly, I considered this the height of philistinism.

The day-to-day manifestations of my father's artistic enterprise were typically quite subtle, as appropriate to the man himself. On rare occasions there were wildly crowded cocktail party/receptions when our house doubled as my father's art gallery. All the members of our family were prevailed upon to serve as his models at one point or another, and when my brother and I found bits and pieces of our toys missing it was not unlikely that they had been spirited away to my father's studio in service of some higher aesthetic cause. But now, twenty-one years after leaving the house at 830 Foucher Street, I find the quiet presence of my father's paintings is woven so deeply into the fabric of my memories that I can no more visualize the house without them than I can imagine it without ceilings or walls.

Over the years I would occasionally happen upon intriguing clues from an earlier era of my parents' lives — a time before the Crescent City had re-tooled itself for optimal tourism, when *la vie boheme* in the French Quarter was cheap and easy, and the streetcar named Desire still ran down Royal Street. The clues are enigmatic and variously manifest: a drawer of old photographs and newspaper clippings; my father's half-century-old aversion to lentils; a mysterious knifeblade deeply embedded, Excaliber-like, in the stout oak base of a table belonging to the parents of a high-school classmate; witty inscriptions from notable authors on the flyleaves of notable books; a trunk full of old Mardi Gras costumes and greasepaints. But in order to give a more complete picture of my father's life and work, this story will reach further back in time, to my father's parents and the days when the Old South lived on, largely unchanged, in rural Louisiana.

My father's father was born in Green County, Wisconsin, in 1874.[1] A widower with small children in the early years of the twentieth century, John Franklin Clemmer left his children with his sister

*John Clemmer,
Donaldsonville, LA,
circa 1925.*

and headed south — first to Texas, and then to Louisiana. By 1917 he was working as an overseer on a plantation near Bayou Goula in Iberville Parish. It was at the town's general store that he met his future wife, Marie Landry — the daughter of a family who traced its presence in Louisiana back to 1785 when Pierre Joseph Landry emigrated from France to America at the age of fifteen.[2] Their attraction was strong and mutual, but any notion of a union between the two was unacceptable to the Landry family. Despite the World War then raging in Europe, the American Civil War that had ended fifty-three years previously remained the defining conflict of this society. John Clemmer was a Yankee and, if that were not enough, a non-Catholic. That might well have been the end of this particular story, had Fate not dealt a hand.

In the fall of 1918 a devastating influenza pandemic — the so-called "Spanish" flu — was sweeping the world. The virus is estimated to have killed between 15 and 25 million people worldwide,[3] and in the United States more than 200,000 died in the month of October 1918, alone. The inhabitants of Bayou Goula were not to be spared. A brother of Marie Landry came home on furlough from the Army, carrying the influenza with him. He died shortly thereafter, and soon the entire Landry family was laid low. John Clemmer, however, was not. He attended the Landrys in their sick beds, nursed them back to health, and when the crisis

was past bluntly informed his former patients that they were to be his future in-laws.

Marie Landry and John Clemmer were married in the spring of 1920 and relocated to Crescent Plantation near the town of Donaldsonville in Ascension Parish. A son, christened John Franklin Clemmer after his father, was born a little over a year later, on July 22, 1921. Two more children, Marie Louise (known as Weatsie) and Dorothy Rhoda Mae (Dot), were to follow. The Landry family's acceptance of John Clemmer Sr. as a son-in-law was grudging at best, and my father recalls that "until the day he died, amongst all of them, my father was always 'Mister Clemmer.' That's as close as they ever got."[4]

My father's recollections of his early years present a compelling mixture of rural idyll and Southern Gothic. A sampling of memories includes returning home from a trip to Lemann Brother's Store in Donaldsonville and burning wrapping paper from packages in the fireplace. A crackling sound from above prompted someone to step outside to investigate, revealing the wood shingle roof ablaze. Family members and plantation workers hurriedly emptied the house of its contents and then watched the building burn to the ground.

My father describes his mother as "a very fine, very gentle and caring woman who had a great deal of empathy for people, as did my father, actually." John Clemmer Sr. was a "very big and powerful man in those days. He was well over six feet tall and very ruddy, and I never knew him that he didn't have white hair."

A hermit trapper lived on the grounds of Delia Plantation (where the family then resided), and Marie Clemmer would give him food and provisions when he stopped by the house. My father recalls that after the hermit had not been seen for some time, Marie Clemmer decided to inquire after him: "We walked out to his shack at the edge of the swamp and he was lying there, dead: He had been bitten by a cottonmouth moccasin. The snake was there — he killed it — but its venom affects your nervous system very quickly, and if there's no one there to help you, that's it. Living back then was very dangerous in many ways."

After the custom of the day, the Landry women would wear black for one year after the death of a family member, and my father relates that his

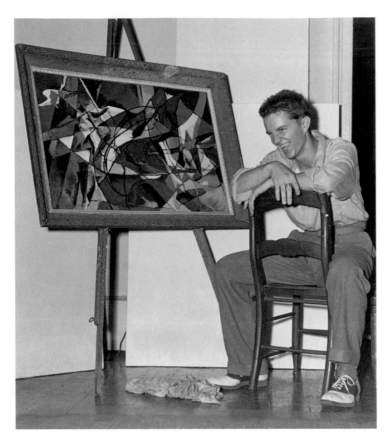

John Clemmer,
New Orleans,
circa 1946,
in front of
See Ungeheuer.

grandmother, his mother, and his aunts rarely had the opportunity to wear any other color.

Both John and Marie Clemmer held progressive social views, and my father characterizes his parents' stance on race relations as being "unique, to say the least," for Louisiana in the 1920s. Some of my father's fondest memories of life in the country revolve around the family's African American nursemaid, Martha, and her husband Adam, a preacher. "On the weekends I used to stay in Martha's cabin with her grandchildren. It was a high point of my life then. Martha always had a rabbit or a possum or a chicken over a low fire with the smoke curling up. When you ate you had black all around your mouth from the soot, but it was marvelous. We slept on cornhusk mattresses." My father describes an occasion when there had been an incident of some sort involving one of Delia Plantation's black cotton-pickers: "I remember being out front with my father and this man comes down the road with a horsewhip. My father said 'What do you think you're doing?' and the man says 'Where's Jesse? I'm here to give Jesse a horsewhippin'.' My father said 'Ohhh, no, you're not.' And the man walked up and said 'Who's gonna stop me?' The next thing you knew he was flat on his back. My mother was very apprehensive

and it was a very tense night, because you just didn't do things like that to other white folk. Word could get around and the situation could get ugly. Nothing ever came of it, though."

The Clemmer family left the country for New Orleans in 1928 and moved into half of a double house on First Street near Magazine, a residence they shared with Marie's unmarried sisters, Cecile (Cis) and Louise, and the Landry women's parents. To his in-laws, John Clemmer Sr. remained "Mister Clemmer" — a proud but frustrated working man who was held as a virtual stranger in his own home. My father relates that his father "was never happy in this environment, but he could do nothing about it. He was a very intelligent person, a nice man, and I recall that he had a beautiful penmanship, but all of his life he had very menial jobs."

For my father, the abrupt transition from country to city was not without its difficulties. New Orleans was still largely a segregated community, and my father lamented to John Sr. that he had no one to play with, for there were no black children living in their immediate neighborhood. A small ruckus ensued when my father presented himself for enrollment at nearby Laurel School: Martha had pierced his ear back in the country (as she did with her own grandchildren), and the principal insisted that the offending earring be

removed before he be allowed to attend classes. John Sr. was furious, but eventually conceded. My father remembers another occasion when a fire drill was staged, and all the children began to leave the building: Assuming that school was over for the day, he simply walked home.

Following the death of Marie Clemmer's father, the family moved around the corner to a house on Magazine Street. It was in this house on the day after Thanksgiving, 1937, that a gas explosion, apparently caused by a faulty heater, tore through the upper floor of the home. Marie Clemmer was mortally injured, as was her elderly Aunt Nanoon, and John Clemmer Sr. was badly burned. My father, sixteen years old at the time, was playing ball down the street and came running when he heard the explosion. It was a shattering event for the family, and my father relates that his father was "in many ways a broken man after this."

John Clemmer Sr. eventually recovered from his injuries and was able to return to his job as a night watchman on a river dredge. Hoping to help secure his son a better life, he petitioned the family's benefactor — the neighborhood tax assessor and political boss — for assistance. In 1939 he was able to obtain a commission for my father to attend the US Coast Guard Academy. (My father's half-brother, William Lee Clemmer, had been a Lt. Commander in the Coast Guard before dying tragically in a flying boat accident in July of that same year.) By this time, however, my father had some ideas of his own about what the future would hold. As for his early interest in art, he says simply, "I had always drawn," and it came as an unexpected and terrible shock to John Sr. when his son turned down his magnanimous offer. My father's family could hardly have derived much comfort from the alternative career he now chose to pursue.

The Arts and Crafts Club of New Orleans was founded in the 1920s with the patronage of Sarah Henderson, the daughter of a wealthy local family that had made its fortune in the sugar-refining business. My father describes the Arts and Crafts Club as "where modern art was shown in the French Quarter — it was the only place of its kind around. In those days the museum, which was then the Isaac Delgado Museum, was a sort of reposi-

tory for whatever people wanted to donate. The Arts and Crafts Club showed traveling exhibitions that were mounted by the Museum of Modern Art and the American Federation of Arts. The people connected with the Arts and Crafts Club were wealthy Uptown people who came to the French Quarter for their entertainment and sometimes their edification, in terms of enlightenment in what was going on in contemporary art." The Arts and Crafts Club also operated the New Orleans Art School, and, following his graduation from Fortier High School in 1939, my father accepted the offer of a scholarship to attend classes at this seminal French Quarter institution.

My father describes his introduction to the Vieux Carré in the late 1930s thusly: "I remember the first time I took the streetcar down to Canal Street and walked into the French Quarter, I thought to myself 'My God, this is something!' It was like going into the Casbah. Streetcars still ran through the Quarter back then, and all the corners were lit with gas lights. I met exotic people like Paul Ninas and Ricky Alferez — real artists, you know — and they were all down there living this bohemian lifestyle…. I was absolutely intrigued by it. It was a marvelous place."

My father began his studies at the New Orleans Art School and found part-time employment in the frame shop at the Gresham Gallery on Royal Street. With a Scots friend named John Minty, he rented a room in the St. Anne Street apartment of ceramicist Rudolph Staffel. Staffel was an instructor at the Art School, as were the painters Julius Woeltz and Paul Ninas, who served as the school's director. Also associated with the school were Enrique Alferez and Xavier Gonzales. Ninas, who had studied in Paris in the atelier of André Lhote, was the central figure in the city's progressive art scene, and my father remembers him as "a very exotic creature." Ninas's father had taught at the American School in Beirut, and Ninas himself had owned a plantation on the island of Dominica.

In addition to being an inexpensive and picturesque haven for artists and eccentrics, as well as ordinary working New Orleanians, the French Quarter attracted an extraordinary array of the cultural luminaries of the day. During the 1940s and 1950s my father encountered many noteworthy people — often through the Arts and Crafts Club,

other times by mere chance. Among the names that appear in his reminiscences are Ernest Hemingway, Josef von Sternberg, Evelyn Waugh, Clarence John Laughlin, Tennessee Williams, Henry Miller, William Faulkner, Randolph Churchill, Abraham Rattner, Thornton Wilder, and Weeks Hall.[5] One notable acquaintance who became a lifelong friend was Hazel Guggenheim McKinley, the younger sister of the legendary gallerist and patron of the arts, Peggy Guggenheim. It was through Hazel that my father met one of the few artists who he cites as a direct influence on his own work: Max Ernst. Home on furlough while serving in the Air Force in the mid-1940s, my father stopped by the Arts and Crafts Club and happened upon Hazel and Ernst (who was, by this time, Hazel's former brother-in-law). My father recalls Ernst in a white angora sweater, sitting in a chair with cigarette in hand, smoke performing mysterious arabesques in the air above his head. An excursion to show Ernst some of the bayou country was arranged, and my father went along. At one point Ernst shouted, "Stop the car!" Leaping out to take in the swamp with its cypress trees and Spanish moss, he exclaimed in his thick German accent, "Mein Gott! I've been painting this all my life! It exists! It's here!!"[6]

While attending classes at the New Orleans Art School, my father used the Clemmer family home near the Garden District as a stopping-off place for naps and baths, but he had been painfully estranged from his father since turning down the Coast Guard Academy. One day at the Art School, Paul Ninas came into the studio and told my father that someone was there to see him. Waiting outside was John Sr., hat in hand, with an apple pie in a box: a truce offering.[7] Father and son had a tearful reconciliation, but it was to be tragically short-lived. John Franklin Clemmer Sr. suffered a heart attack on May 10, 1941, and was taken to the Hotel Dieux hospital. Refusing an offer of last rites from the Sisters, he died with his three children at his bedside.

A little over a month later, my father married Marjorie Fischer, a French Quarter habitué whom he had met at the Gresham Gallery. Husband and wife were both very young and the marriage was an impetuous one. The union was destined to failure, but not before it produced two children: Trina, in 1942, and Erik, in 1945. Following the wedding, my father worked for a while at Higgins Industries near City Park, spray painting landing craft and PT boats; by this time, the United States had entered World War II.

My father was inducted into the US Army in January 1944, and went through basic training at Fort Livingston in northern Louisiana, where he marched about for weeks with a wooden gun, wearing the same herringbone tweed suit in which he had arrived. He was assigned to the Army Air Force and eventually stationed to Air Force head-quarters at Wright Field (now Wright-Patterson Air Force Base) in Dayton, Ohio. It was at Wright Field in March of 1945 that PFC Clemmer received a letter from home informing him that he had won First Prize in the Arts and Crafts Club of New Orleans' annual juried exhibition — the first of many such honors and recognitions.

While in the Air Force my father continued to draw, and organized open drawing classes at Wright Field when the base commander decided that he wanted his children to study art. Attached to a Colonel Putt, my father traveled around the country producing organizational charts as the Army Air Force became a separate branch of the military. Colonel Putt offered to recommend his young assistant for Officer Candidate School, but the offer was declined and Corporal John Clemmer was mustered out of the service in January 1946. At the urging of Xavier Gonzales, he seriously considered heading for New York to study at the Art Students League under the G.I. Bill. After spending a long and tormented day in the Dayton train station weighing his options, he returned to New Orleans to attend to his children. Although a final divorce decree was not issued until the summer of 1947, the relationship with Marjorie had effectively been over for a long time.

As young men returned home from military service with the G.I. Bill to aid in their academic pursuits, the New Orleans Art School was poised to significantly expand its enrollment. My father accepted the dual position of Executive Secretary of the Arts and Crafts Club and Director of the Art School. With his infant children, he moved into the top floor of the three-story building at the corner of Pirate's Alley and Royal Street that was home to the Arts and Crafts Club. A relationship evolved between my father and an Art School model and

aspiring dancer by the name of Elizabeth (Litza) Scoville, and before long she too moved into the building. In October 1947, when their cohabitation became a matter of concern to the Arts and Crafts Club's board of directors, John Clemmer and Litza Scoville were married.

Around this same time, my father began to supplement his income by painting sets for Mardi Gras balls. This eventually led him into the Mardi Gras mask business — an enterprise that has left an indelible impression. A 1953 *New Orleans States* article is illustrated with a photo of my father seated glumly before a pile of his handmade Mardi Gras masks. The first sentence of the article states "When friends ask John Clemmer 'Are you masking for Carnival?' he shudders and changes the subject immediately."[8] (Forty-six years later, prodding my father on his involvement with the business side of Carnival elicits an essentially identical reaction.) While lamenting his servitude to the Mardi Gras krewes, he remarks ruefully in the same article that the mask industry is "more lucrative than serious painting. Almost anything is."[9]

As an increasingly prominent — if impoverished — artist and the primary administrator of the Arts and Crafts Club and its school, my father found himself cast in the role of local spokesperson for the cause of modern art. In the spring of 1950 he engaged in a cordial but hard-nosed public debate with Carter Stevens, art critic for the *New Orleans Item,* on the merits of abstract art. In an article entitled "Abstract Art: Has It Gone Too Far?" Stevens stated, "This writer does not believe that abstraction has an enduring place in painting, sculpture, and other art mediums."[10] Stevens' views were certainly not unique, and my father recalls that, "There was absolutely a great controversy and conflict about abstract versus representational art — people felt very strongly about it then. If you painted real American things, fine, but otherwise it was, 'You're one of those communist artists, aren't you?'" Despite Carter Stevens' admonitions, 1950 proved to be a watershed year, marking the ascendency of Abstract Expressionism — the first genuinely American modern art movement — and the attendant shift of the center of the art world from Paris to New York.

Despite the advances being made elsewhere in the art world, by 1949 the Arts and Crafts Club

of New Orleans was beginning to wind down. Enrollment at the Art School was dwindling, but among the new students attending the night drawing classes taught by my father were a young couple, Frank and Dorothy Lossy. Fifty years later, Dorothy Clemmer recalls being amused and somewhat taken aback by her future husband's reaction to the drawings of a student who consistently rendered the models with odd distortions: massive torsos, long thin limbs, tiny heads. After perusing the student's sketch pad my father considered what he had seen for a moment and commented, "Well, they all seem to have the same disease."[11]

The eldest of three children born to Charles and Sarah Iker, my mother was brought up in a highly cultured Jewish household in the comfortably middle-class Rogers Park area on Chicago's north side — circumstances that could hardly have been more different from those of my father. An exceptional student, Dorothy Iker had enrolled in the College of the University of Chicago at the age of fourteen and was married to Frank Lossy at eighteen. The couple moved to New Orleans in 1947, when Frank accepted an internship at Touro

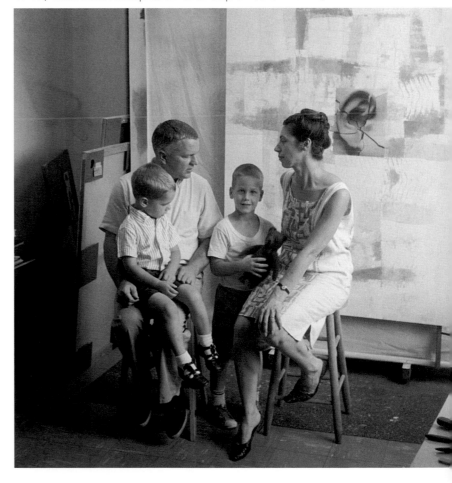

John Clemmer with sons David (left) and Jonathan (right) and wife Dottie in front of Almedia, at Foucher Street studio, circa 1963.

Infirmary. By early 1953, both my mother's marriage to Frank and my father's marriage to Litza had ended in legal separations followed by divorce.

The ivy-traced gentility of Tulane University might have seemed worlds away from the Bourbon House, Cafe Lafitte, and other such haunts of French Quarter bohemia frequented by my parents and their friends, but in 1951 the University extended a hand to my father. The hand was that of Buford Pickens, Dean of the School of Architecture, who had been engaged to help the program recover from the loss of its accreditation. My father recalls Pickens stating, "'Our students need to learn how to draw. The slide rule and the T-square are fine, but these kids have no sense of form.' I went up and taught part-time at the School of Architecture, and things evolved from there." The relationships that developed at this time — with Dorothy (Dottie) Iker and Tulane University — proved to be the most significant and enduring of my father's life.

My parents were married on December 19, 1953, and honeymooned briefly at the Gulf Hills Dude Ranch on the Mississippi Gulf Coast. The newlyweds celebrated with champagne on the train ride, triggering an allergic reaction in my mother that left her gasping for air and wondering if she would survive the journey. Despite some initial skepticism regarding their new son-in-law, Charles and Sarah Iker soon developed a strong and affectionate bond with the young man who had lost both of his parents by the age of nineteen.

The couple continued living in the French Quarter at my mother's Dumaine Street apartment, and began to save money for a real honeymoon. By early 1955 they were ready to sail for Europe on the *New Amsterdam,* but an opportunity arose that resulted in a change of plans. My parents learned of a house that was going up for sale as the result of the divorce of a couple with whom they were acquainted. It was a large camelback Queen Anne cottage built in 1892, located at the corner of Foucher and Laurel Streets on the site of a former brickyard. Surrounded by a dense hedge and a wrought-iron fence, the property included a small additional building ideally suited for an artist's studio. Reservations were cancelled and ocean liner tickets cashed in, a downpayment was made on the home, and the honey-

moon was postponed until the following year.

By 1957, my father was in his sixth year as an Instructor in Art at Tulane. He was strongly influenced by the ideas of Laszlo Moholy-Nagy and his colleagues at the Bauhaus, and campaigned successfully for a workshop so the architecture students could "get off the drafting table and learn to use their hands." He was able to maintain a second studio on campus, and continued to paint while developing his interests in three-dimensional design. My mother was in the final year of a doctoral program in microbiology at Tulane. She was also pregnant with her first child, and on September 27, my brother Jonathan was born at Touro Infirmary, just a few blocks up Foucher Street from our family's home.

In early 1957, at the invitation of Tulane faculty member Pat Trivigno, Mark Rothko spent two months in New Orleans as a Visiting Artist at Newcomb College. My parents struck up a friendship with Rothko and his wife, Mell, and socialized with the couple on subsequent trips to New York.[12] As one of the few Tulane couples with a house large enough for proper entertaining, my parents were host to many parties attended by prominent artists and architects who were visiting the university.

The Clemmer family continued to grow with the addition of a succession of hound dogs, and with my own arrival on October 2, 1959. In 1958, my mother had accepted a position as Instructor in Epidemiology at Tulane's School of Public Health and Tropical Medicine. Luckily, the difficulties of two working parents with infant children were made manageable by our beloved nanny and housekeeper, Irma Griffin. Summer vacations were spent at a small cottage in Sheboygan, Wisconsin, that my mother's father had purchased in 1939. Over the years, Wisconsin came to play an increasingly significant role as a refuge for my father to work, and as a source of artistic inspiration.

By 1974, both of my parents had attained full professorships at Tulane. My father was appointed Chairman of the Department of Art at Newcomb College in 1978 — a position that he held until his retirement in 1986. My mother retired from Tulane in 1989, after spending thirty-nine years with the university. Like my parents, my brother Jonathan and I have gravitated to careers in medicine and the arts, respectively.

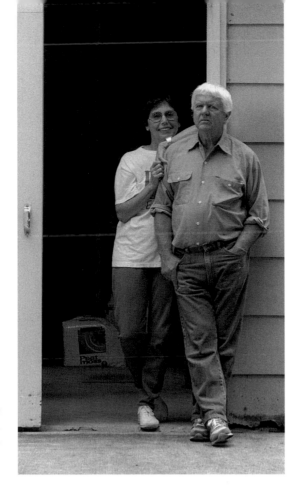

Artist and wife Dottie outside the Sheboygan, WI, studio, 1997.

In September 1998, I visited my parents in Wisconsin, where they now spend approximately half of their time. On land adjoining the original Iker property, they have renovated a house, and my father spends his days in a pristine studio of his own design outfitted with large north-facing clerestory windows. I sat there with him for hours over the course of several days, watching him draw while he talked about his life, his family, and his work.

My father reminisced about his childhood pet (a pig named Sandy), seances at Clarence John Laughlin's apartment in the Pontalba, and seeing Picasso's *Guernica* at the Isaac Delgado Museum while the painting was on tour to raise funds for the Loyalists during the Spanish Civil War. He discussed the subjects of his paintings ("The subject is paint"); how to know when a painting is finished ("You don't—you just stop working"); and two painters he considers to be among the greatest of the twentieth century—Pierre Bonnard and Richard Diebenkorn. Acknowledging the often hermetic nature of the artist's endeavor, he noted, "I guess I'm somewhat misanthropic. Being alone and working is, to me, delightful." His rather stoic and reserved nature is balanced, however, by a lively sense of humor, an appreciation for the small absurdities of life, and a boundless enthusiasm for the things he holds dear, including the world of

images, Mozart, clean and orderly surroundings, and my mother.

For many years my father has kept a cartoon clipped from the *Saturday Review* pinned up in his New Orleans studio. It depicts an artist standing in front of a canvas, preparing to commence a portrait of the subject seated before him. The artist cautions his sitter, "Steady now, Mr. Hartzfeld, while I grope for the inner man." The story of my father's life provides valuable context for a fuller appreciation of the man and his art, but through his instinctual reticence the private John Clemmer remains an ever-elusive subject. Perhaps paradoxically, the most revealing intimations of the inner man are to be found in those expressions of the self that he has spent a lifetime offering to the world for contemplation: his paintings.

1. For valuable assistance with details on family history I am endebted to my father's sister, Marie Louise Dorsey, and to her daughter-in-law, Mary Dorsey, the Landry/Clemmer family genealogist.

2. Pierre Joseph Landry (1770-1843) commanded a company of men in the Eighth Louisiana Regiment in the War of 1812, and fought in the Battle of New Orleans—the last major engagement of that conflict. Landry took up wood carving after suffering a knee injury, producing a variety of sculptures in an accomplished yet engagingly "naive" style. Examples of Landry's carvings can be found in the collections of the New Orleans Museum of Art, the Louisiana State Museum, and the Hermitage in Nashville, Tennessee.

3. W.I.B. Beveridge, *Influenza: The Last Great Plague*, New York, 1977, Prodist/Neale Watson Academic Publications, Inc., 31-32.

4. Conversation with the artist, September 1998. Unless otherwise noted, all quotations attributed to John Clemmer are drawn from the transcripts of these conversations.

5. William Weeks Hall was a noted Louisiana artist, bon vivant, and the owner of Shadows-On-The-Teche, a classic antebellum plantor's townhouse located on the Bayou Teche in New Iberia, Louisiana. Hall's ancestral home was a gathering place for internationally acclaimed writers and artists, as well as for John Clemmer and others associated with the Arts and Crafts Club of New Orleans.

6. Max Ernst and Peggy Guggenheim were married for a brief period, beginning in December 1941 and ending in 1943. See John Russell, *Max Ernst, Life and Work* (New York, Harry N. Abrams, Inc., Publishers, 130), for a theoretical view of Ernst's visits to Louisiana: "From the very first, Max Ernst's years in the U.S. were marked by symbolic adventures of the kind he has attracted throughout his life.... If he visited the swamps near New Orleans he did not simply see the alligators and the snapping turtles and the black cotton-mouth snakes; he was made to clamber above them along a dilapidated railway-track."

7. The offering of an apple pie was of special significance for John Franklin Clemmer Sr. Both apple pie and maple syrup held fond nostalgic associations from his boyhood in rural Wisconsin in the late nineteenth century.

8. Elsie Brupbacher, "No Mask for Man Who Paints Them," *New Orleans States*, February 14, 1953.

9. Ibid.

10. Carter Stevens, "Abstract Art: Has It Gone Too Far?" *New Orleans Item*, April 18, 1950.

11. Conversation with Dorothy Clemmer, March 1999.

12. See James E.B. Breslin, *Mark Rothko: A Biography* (Chicago and London, University of Chicago Press, 1993, 353-55). During his time in New Orleans, Rothko produced what he felt to be two "important 'breakthrough' paintings." These works heralded the darkening of Rothko's palette that was to continue to the end of his career.

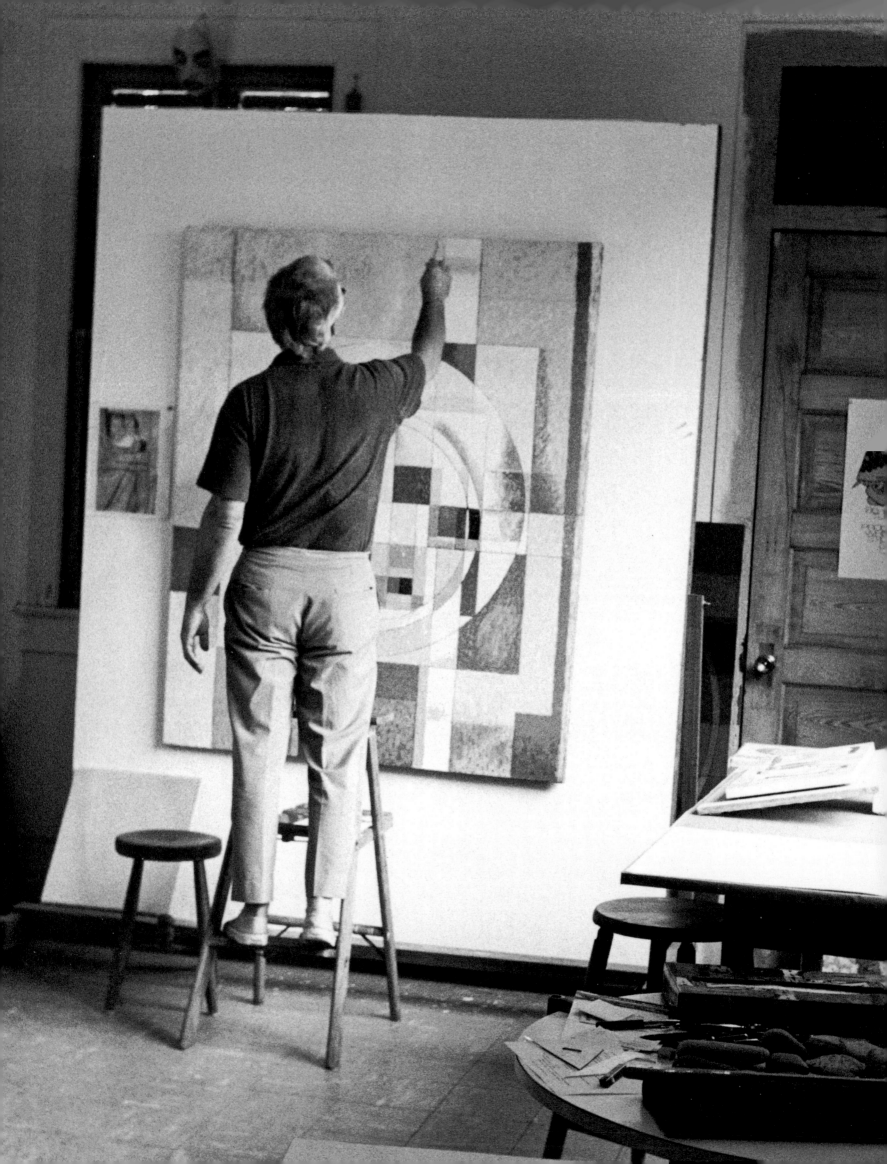

Crafting the Intangible: The Art of John Clemmer

The work of John Clemmer is extraordinarily diverse. After World War II, American artists from Jackson

Pollock to Eric Fischl made international names for themselves by creating consistent, recognizable styles, but Clemmer's work resists any immediate stylistic summation. Yet in reality, retrospective exhibitions of canonical artists like Pollock[1] reveal that it is absolutely typical for an artist to try out different media, various subjects, and different manners over the course of a career. And in the case of John Clemmer, the career has been long and richly productive.

To give some examples: His work during and after World War II, such as *"How Men Their Brothers Maim"*[2] (1942, cat. 2) and *Swamp Fire* (1947, cat. 4), is characterized by emotionally charged, curvilinear brushstrokes combined with thick black outlines that led one reviewer to speak of Clemmer's art as "abstract expressionism done with assurity."[3] By 1973, however, *Topographia V– Capricorn* (cat. 26), displays a more carefully controlled, geometrical structure that might find precedent in Wassily Kandinsky's work of the 1930s, prompting another writer to speak of Clemmer's "austere precision and balanced grace."[4] Perhaps we should not be surprised that when we survey the longer period of more than fifty years represented in this exhibition, we find an oeuvre that seems to refuse neat categorization, with subject matter from pure abstraction, like *Salem Symbol* (1966, cat. 17) to landscapes, such as *Road to Voukari/ Kea* (1992, cat. 51) to portraits like *Portrait–Lin Emery and Shirley Braselman* (1967-68, cat. 21). The media are equally varied: Clemmer has worked in traditional oil painting, acrylic, collage, and sculpture in various materials, to name only a few. For all the varying degrees of abstraction, classic issues are constantly visible, such as the negotiation of flatness versus three-dimensionality, and the desire to be true to each separate medium (a desire linked to the meticulous craftsmanlike handling that is one of the supreme hallmarks of Clemmer's career) while simultaneously "pursuing its potential," as the artist has put it.[5] This is not a painter who permits us to give a quick summary of the physical and formal aspects of his

works in order to move on to an invisible message that must be teased out. Although there are meanings not immediately apparent, they always exist in tension with the artist's ongoing concern with his materials and their precise manipulation, so that the images constantly manifest a quality of exactitude.

Clemmer's works refuse to serve any didactic function, refuse to describe, communicating instead by suggestion and evocation. The artist himself is rarely given to long statements on the conceptual underpinnings of his work, preferring instead to discuss the complex formal choices that lie behind each of his creations. These works of art, however, demand something beyond a discussion of these formal issues. There is a seriousness of purpose and an intensity that is everywhere apparent in Clemmer's work, a certain quiet forcefulness that pervades each brushstroke and line of his art. As much as his formal accomplishment, it is this seriousness that demands to be understood further. If many of the connections that are made are prompted by statements by the artist or details drawn from his biography, equally many must be inferred from the formal transactions of medium, line, and tone—always at the forefront of Clemmer's art.

In order to do that one must place Clemmer within the framework of his period. Throughout the middle years of this century, writers such as Clement Greenberg sought to detail a self-critical trajectory of modern artists in pursuit of entirely formal goals, such as the expression of the flat surface of the canvas that one so often sees in Clemmer's oeuvre. But in the wake of the re-introduction of figural subject matter during the Pop Art movement,[6] the appearance of semiotics and post-structuralism as critical perspectives after the so-called linguistic turn, and the cultural hegemony of post-modernism dominating art at the end of the century, the notion that any artist can be discussed in purely abstract terms ceases to satisfy. Despite the rhetoric during the heyday of Abstract Expressionism, when Robert Goodnough could claim that artists of that movement were "involved

BY GRIDLEY McKIM-SMITH AND LEO COSTELLO

in an experience of paint and canvas, directly, without interference from the suggested forms and colors of existing objects,"[7] today even the most seemingly abstract artists are seen to have made veiled reference to figures or compositions from the traditions of representational painting. Mark Rothko's softly-edged geometric colors are said to echo renderings of the universe in theosophical and occult images as well as designs by artists such as Jan van Eyck,[8] and Jackson Pollock's drip paintings are revealed to have begun with drawings of faces and bodies.[9]

These more-recent claims are not made without controversy. But the point for viewers of John Clemmer's art is that his paintings do not require that we adjudicate that problem because he never loses touch with the European tradition of representational painting. It is not surprising that Clemmer would exhibit such a connection. He studied for three years with Paul Ninas, a Missouri native who worked in the important Parisian studio of André Lhote in the 1920s and introduced the formal innovations of twentieth century French art to New Orleans when he came to live and work there in the 1930s.[10] Doubtless, Ninas was exposed to Henri Matisse. In *The Blue Window* (1913) [Fig. 1], Matisse experimented with the traditional format of the window that opens onto a landscape. While Matisse uses line to suggest the recognizable forms of table, window, ground, and tree, he does not vary the color of these objects correspondingly, instead describing them all in shades of deep blue.

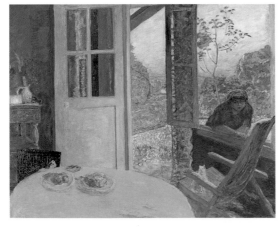

The result is an image that suggests objects in space, but remains tied to the two-dimensional surface of the canvas. Similarly, in his *Dining Room in the Country* (1913) [Fig. 2], Pierre Bonnard, an artist for whom Clemmer has expressed admiration,[11] uses a window opening onto an exterior to explore flat, decorative planes of color and the two-dimensional qualities of paint on canvas.[12] Clemmer's enduring awareness of the work of Matisse and the School of Paris, as well as later variations on the "window" theme by Richard Diebenkorn,[13] is still visible in *San G. I* (1991, cat. 46). In this image, Clemmer uses Matisse's, Bonnard's, and Diebenkorn's open window format. Like a true artist of the twentieth century, Clemmer suggests all the traditional elements of the scene — green grass, blue sky, and the window pane in the white, pink, and brown vertical and horizontal elements — only to deny their fictive presence by refusing to offer the expected delineation of three-dimensional space. Instead, the colors, applied in the delicate layers so typical of his later work, remain firmly tied to the flat canvas.

The way Clemmer incorporates these references, however, shows something beyond the fact that like all artists, he participates in the thinking of his time. Regardless of the specificity of the reference (or lack thereof), his works exhibit an ongoing involvement with a kind of interiority that is as prominent as his involvement with abstraction, with medium, and technique. Although Clemmer has worked on a number of religious commissions, it would severely distort the deliberately secular and often hermetically erudite content of the works in this exhibition to connect them specifically to any organized religion. It can nevertheless be said that his works speak of a private language that links them to a dimension of what must be carefully termed spirituality.[14] Such a concern was in fact common to many artists of the twentieth century, both in Europe and America.[15] The beginning of the twentieth century saw enormous changes in the Western world. Increased speed of transportation and communication as well as increasingly crowded and impersonal cities fundamentally changed the way people related to the world around them. If John Clemmer has inherited aspects of the European formal tradition, he has also been the heir to some of its thematic concerns,

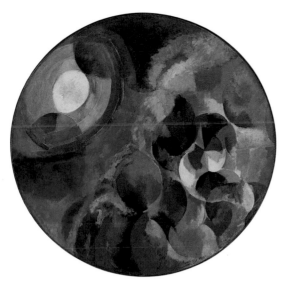

Figure 3
Robert Delaunay
Simultaneous
Contrasts: Sun
and Moon, *1912.*
Oil on canvas.
53 inches diameter.
The Museum of Modern
Art, NY. Mrs. Simon
Guggenheim Fund.

including these dislocations. It has been suggested, for instance, that the French painter Robert Delaunay reacted to these changes by seeking to create a new sense of unity between man and the cosmos that surrounds him.[16] In particular, Delaunay sought to use perceptual experience as a means of establishing a new kind of connection between man and the objects and actions of the world. In images such as *Simultaneous Contrasts: Sun and Moon* (1913) [Fig. 3], Delaunay used the structuring device of the circle to unify all of the colors perceived in nature into one image. Doing so allowed him to suggest the diversity and movement of the natural world, while bringing them together in harmonious tonal balance: a world unified by a viewer's perception of the circle.[17] It is just such an expression of a conceptual relation to the universe that John Clemmer has attempted to forge throughout his career. Clemmer also relates geometric forms to a natural scene to express the unity that he finds between humans and the world around them. As did Delaunay and Matisse, however, Clemmer has sought also to maintain the primary reality of the painted canvas as a two-dimensional object with laws and harmonies unto itself. Thus the formal and the thematic have a simultaneous harmony of their own.

This interest in finding a place for humanity in the modern world was an important issue for other American artists in the period during and after World War II. Reacting to the terror of unprecedented devastation and loss of life, as well the inhuman destructive capacity of the atomic bomb,

many artists began to focus on an investigation of the spiritual condition of humanity in the face of the horror of the modern world. It is no accident that *"How Men Their Brothers Maim,"* with its dark palette and distorted facial expression, should date from the war years. There is also an inescapable reference to the Man of Sorrows, a reference which is more legible in the drawing [Fig. 4], where the crown of thorns is not absorbed into the overall pattern of black lines that characterizes the painting.[18] Clemmer shares the concern registered in *"How Men Their Brothers Maim"* with many Abstract Expressionists. The means of relating to these issues, however, was very different for an artist like Pollock, for whom it was to be found in the investigation of the unconscious. Pollock began, in the early 1940s, to experiment with the Surrealist technique of automatic drawing as a means of accessing unconscious drives and passions.[19] Incorporating mythic imagery and themes, as well as theories of Jungian analysis, Pollock continued over the next decade to explore his unconscious as a means of situating himself in a perilous and troubled modern world.[20] Painting thus became a means of locating the emotional and psychological position of the individual in the twentieth century.

This renewed focus on the place and experience of the individual during and immediately after World War II may be further contextualized

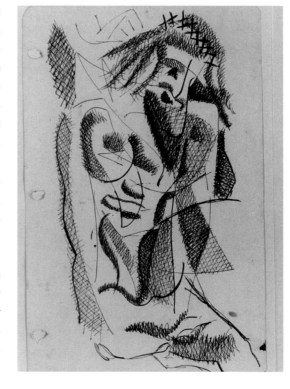

Figure 4
John Clemmer
"How Men Their
Brothers Maim,"
1942. Sepia ink
on paper.
9¹/₂ x 6 inches.

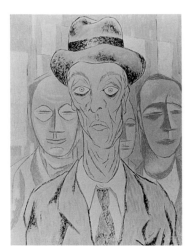

Figure 5
John Clemmer
St. Charles
Streetcar, 1951.
Casein on paper.
26 x 19 inches.

historically via a much discussed aspect of American society at that time: "alienation." While large sectors of the American population achieved tremendous economic prosperity as a result of the nation's enhanced post-war status, these same changes also created widespread feelings of isolation and disaffection. "Alienation," or loneliness, and feelings of dysjunction were common themes in both the literature and sociology of the 1950s and 1960s.[21] In *Man Alone,* a sociological study of 1962, for instance, Eric and Mary Josephson describe the increasingly specialized and mechanical nature of blue-and white-collar work, governmental bureaucracy, the decline of religion, and feelings of insignificance in relation to a mass society.[22] These issues, largely common to post-Industrial Revolution capitalist nations, were particularly acute in the rapidly expanding economy and changing society of the post-war United States, and led to feelings of powerlessness and separation from oneself, from others, and from the world as a whole.[23]

John Clemmer negotiates these issues in his portraits and figural studies of the 1940s and 1950s. In *St. Charles Streetcar* (1951) [Fig. 5], for instance, the anonymity and perhaps even hostility of interpersonal relationships in the modern city is registered in the wide eyes and gaunt face of the man in the foreground, a sort of Man in the Gray Flannel Suit, now become distant and even threatening as he looms large in the foreground. The figures in the back are equally inaccessible, their faces abstracted into masks, perhaps referencing what Clemmer saw every year during Mardi Gras.[24] These figures also recall the mask-like grimace of another familiar New Orleans figure, the *Harlequin* of 1947 [Fig. 6]. The inapproachability of the Harlequin, as well as that of the equally theatrical players in *Two Figures – Macbeth* (1949, cat. 7), and the insurmountable distance between persons in the modern world, is found again and again in Clemmer's figural work of the years to follow. Aside from the abstraction that overwhelms the specific features of figures like that of the Picassoesque *Seated Nude* (1951) [Fig. 7], our access to them

is blocked again and again in images such as *Two Nudes in a Landscape* (1949, cat. 8) and *Kneeling Nude* (cat. 6) of the same year, where the figures, though centrally located, have their backs turned to the picture plane.

Even when Clemmer works in a more representational language, there remains an implicit tendency towards abstraction that speaks of a distance between artist and sitter. In *Portrait – Charles Bowen* (1950, cat. 10), the sitter is rendered with careful and almost unforgiving attention to the particulars of appearance. At the same time, however, the features of his face and the lines of his jacket and tie are subtly incorporated into the pattern of the background, thus detaching them from the flesh and bone of the sitter. These two impulses — the drive to realistic precision and the will to abstract — exist simultaneously in the work, but also mark the complexities of interpersonal relationships, giving the painting the quiet tension that makes it such a powerful image.[25] If this distance between humans is inevitably present and expressed here, however, there remains Clemmer's desire to overcome this distance and a sort of tenderness (though never sentimentality) that colors particularly his portrait work. In *Portrait – Lin Emery and Shirley Braselman*, the female figure occupies almost the entire left half of the canvas, placed very close to the picture plane. Lin is, in fact, a fellow artist whose work Clemmer deeply

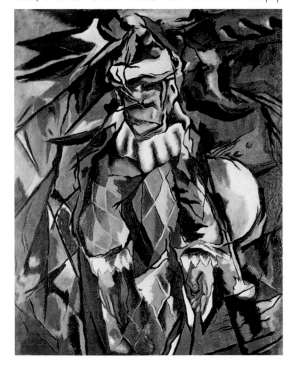

Figure 6
John Clemmer
Harlequin, 1947.
Oil on canvas.
36 x 26 inches.

respects. Particular attention is given here to the lines of her right hand, the artist's instrument, hers and his, placed closer to the picture plane (and to her first viewer, Clemmer) than any other part of her body.

Not to give a reductive account of the appearance of genuine modernist elements by linking abstraction with alienation, it must nevertheless be noted that there is a clear and important break in the 1950s with the dark, violent and sometimes chaotic abstraction of the 1940s. The *Nude with Still-life* (1951, cat. 11) substitutes a figure of classicizing tranquility for the jagged and disintegrating planes of *Two Figures—Macbeth*. In the 1950s, forms are conceived with a meticulous economy. This lays a firm foundation for Clemmer's most characteristic and most beautifully equilibrated production in the 1960s and early 1970s. From the balanced harmony of *Bookshelf* (1960s) to the controlled witticism of the collaged *Almedia* (1962, cat. 19), to the masterpieces of the *Topographia* series, Clemmer's style has crystallized, and from this time forward his paintings have a look that marks them as recognizably his. With what is by now a fully formed style, he works to create paintings of a controlled geometry, such as *Topographia—Capricorn*, but he nevertheless includes exquisitely placed passages of luminous squares and slices of color, producing an unforgettable combination of the cerebral and the sensual.

As we move towards the later works, it is useful once again to place Clemmer's images in the context of social issues, revisiting the question of alienation and noting that one of the areas most affected by changes in society was what might be referred to as spiritual life. In a United States that was increasingly secularized, religion came to play a steadily diminished role in people's lives. This, of course, has been a general condition of modern society since the Industrial Revolution. Authors during the 1950s, however, suggested that this lack of a religious framework contributed to the feelings of alienation that were so much a part of 1950s discourse. William Barrett, for instance, noting the importance of the medieval church to human spirituality and mankind's sense of relation to a psychic and spiritual world, wrote in 1958: "The loss of the church was the loss of a whole system of symbols, images, dogmas, and rites which has the psychological validity of immediate experience and within which hitherto the whole psychic life of Western man had been contained. In losing religion, man lost the concrete connection with a transcendent realm of being."[26]

In this context, the work of John Clemmer and his contemporaries comes even more into focus. Clemmer has conceived of his work in a manner very much like that of images in the early Christian church: as a means of establishing a place for the viewer within the spectrum of the universe. Let us be very clear: In no way can the art in this exhibition be called religious. Instead, Clemmer's works seek to connect the individual to the cosmos in a profoundly secular fashion, by stressing the intensity of the experience of the artist and by seeking the formal means to communicate that experience to the viewer.[27] This communication then brings his private experience beyond the plane of the individual and into the realm of the collective.

"How Men Their Brothers Maim" is almost unique in Clemmer's work in its citation of a specific religious iconography. This iconography recurs, albeit less explicitly, in much of Clemmer's later work, beginning perhaps with the *Topographia* series, begun in 1969. In *Topographia II—Atitlán* (1969, cat. 23), and *Topographia III—Guatemala* (1969-70, cat. 24) the circle, inscribed in a square, determines the structure of the painting. At the first level, Atitlán was a sacred site to the Mayas. In a European context, the circle has, since the Renaissance, been associated with divinity, thought to express the perfection of God.[28] Even more, for the Romans, however, the circle combined with the square was considered to be an expression of the harmonious relationship of the parts of the body and, analogously, of the parts of architecture and the balance between the two, as for instance, in the Pantheon, where the dome is perfectly hemispheric and thus can be contained within a square.[29] Perhaps closer to Clemmer's meaning here than either of these models is that of Galileo who, in the seventeenth century, conceived of the universe as structured by interwoven geometric shapes that

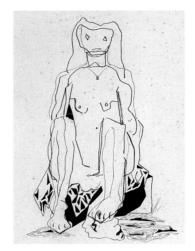

Figure 7
*John Clemmer
Seated Nude,
1951. Ink
on paper.
10 x 7 inches.*

25

humanity must learn to move and work within. Galileo wrote:

Philosophy is written in this grand book — I mean the universe…. It is written in the language of mathematics and its characters are triangles, circles, and other geometrical figures without which it is humanly impossible to understand a single word of it; without these one is wandering about in a dark labyrinth.[30]

This dual humanist and religious iconography is invoked in two of Clemmer's most accomplished works, *Topographia IV–Cosmas II* (1970, cat. 25) and *Topographia V–Capricorn*, both dominated by a series of circles. In a statement of 1971, Clemmer noted the importance of Byzantine art and, in particular, two ninth-century copies of earlier manuscripts, one by Cosmas Indicopleustes, a sixth-century Alexandrian scholar, and the other by Ptolemy, the second-century Roman mathematician and astronomer.[31] While both Cosmas and Ptolemy were concerned with topography and charting the known extents of the world, Cosmas' manuscript sought to understand the universe in terms of the places and models described in the Bible, whereas Ptolemy's text was pagan and attempted to come to an understanding of the world based on mathematics and science.[32] It is typical of Clemmer to merge a Christian and pagan source and in each case we see humanity attempting to come to grips with the world above, below, and around it, and trying to find its own place within that world. Clemmer's work may similarly be seen as a sort of topography or cosmography, exploring the various physical and spiritual terrains of the universe and seeking to convey a sense of the relationship and position of humanity within them, seeking to find order and balance. This equilibrium is forged in the rings that determine the spaces of the paintings. Clemmer uses color, chosen with his usual care for tonal balance and harmony, to emphasize the various shapes created by the juxtaposition of the circles with interior squares. This geometric structure, particularly the concentric rings of *Topographia IV–Cosmas II*, is reminiscent of the illustrations for the Byzantine copy of Ptolemy, which show the celestial deities at the center of a group of circles, giving form and structure to the heavens, to the world of

the spiritual. As in the Ptolemaic manuscript, geometry in the *Topographia* series has become a means for humanity, painter, and viewer, now positioned in front of a painting, aligned with its centralized composition, to understand the topography of the world and find a place within it, incorporated into a finely tuned structure of geometry and color.

The juxtaposition of motifs from different religious traditions, as well as geometric forms, continued to inform Clemmer's work in the 1970s, 1980s, and 1990s. Beginning in the late 1970s, Clemmer often divided his canvases into geometric sections.[33] Particularly in the work of the 1990s, these sections often bisected or trisected the canvas, as in *Triunity I* (1995, cat. 53) and *Birches–Duo* (1996, cat. 56), invoking the traditional diptych or triptych form of the Christian altarpiece.[34] Although in past centuries this format served to signal the viewer that the work is of spiritual significance, in *Birches – Duo* the religious format is placed over a secular subject, a landscape in which the imagery exceeds and overflows the boundaries of the sections. Even more interestingly, in *Temple of Poseidon I* (1992, cat. 52), Clemmer imposes the Christian triptych format onto a view of a pagan temple. Clemmer here evokes two separate religious traditions, in order to convey a message of broad spirituality to the viewer, a message that undermines divisions between various belief systems and suggests that all are a means of orienting humanity to "a transcendent realm of being," to recall William Barrett's phrase. We are asked here to stand before the altar in a church and before the façade of a Greek temple.

Such images also seek to evoke the variety and changeability of nature, but only to unify it by an overarching conception of the universe as an abstract whole. This is emphasized throughout Clemmer's oeuvre by his carefully calibrated color harmonies. In *Temple of Poseidon I*, Clemmer establishes a dominant color tone within each of the three sections. Though done largely in oil, the paint is applied in thin veils of translucent colors. The section at the left is dominated by a range of yellow tones suggestive of early morning, the middle in the pale blue of the bright Mediterranean midday, and the far right, the lavenders and violets of dusk. Thus, while the temple itself is a monumental, static structure, Clemmer introduces temporal

movement through color, moving back and forth across the canvas. Each section, however, is in close harmony with the other. The dominant yellow of the left-hand division recurs in the columns of the other two. Further, although Clemmer uses a very restrained palette here, there is extraordinary range within the individual tones, and each of the variations is carefully balanced against, and complemented by, the tones in the other sections. Thus while there is difference and progression in the day, there is also unity. Clemmer suggested precisely this in 1971 when he noted that while he painted many geographical locations, "...in each there is the development of a geometry peculiar to place—an expression of the unity of man and the universe."[35]

It is useful at this point to return to a comparison of Clemmer's work with that of the Abstract Expressionists. Despite the fact that a number of them acknowledged that their art sprang from the sensations of New York City, they were avowedly not landscape painters. That is to say, they concentrated their efforts on the exploration of their inner psyche rather than concerning themselves with their reactions to particular scenes or sites. John Clemmer, on the other hand, has long been concerned with expressing his reactions to specific places. In *Temple of Poseidon I*, for instance, Clemmer carefully situates the viewer, so that there can be no mistaking that a specific spot is being occupied. We are given but a partial view of the ruined structure, which is too large to fit in the frame of our view. Furthermore, the closest façade looms high over the spectator, while the one behind takes a much lower profile against the sky. Because of the low viewpoint, the physical presence of the building and the actual occupation of the space before it by artist and viewer are undeniably communicated. In a statement of 1971, during an exhibition of many of the *Topographia* paintings, Clemmer spoke of this emphasis on place:

This exhibition is composed principally of works expressing a response to and an expression of the qualities of place—combinations of states of being of the perceived and the perceiver. They are not observations, expressions of specifics, of 'realism'; not observations but perceptions of place, expressions of

the quality of light, air, color, movement, constancy, variability, time, and timelessness.[36]

Here Clemmer's work recalls the Romantic landscapists of the early nineteenth century. While John Constable is thought to have adopted a "scientific" attitude to rendering nature, he was concerned with the expression of emotions stirred before a natural scene:[37] "Painting," Constable wrote in a letter of 1821, "is but another word for feeling."[38] For Clemmer this engagement with landscape, however abstractly represented, also indicates his desire to explore his experience of the natural world. An important part of this process has to do, as it did with Constable, with an evocation of the specificity of natural conditions. While Clemmer does his final work in the studio, he has suggested that in his landscapes he seeks a sense of the instantaneous glimpse.[39] For all of the monumental qualities of *Temple of Poseidon I,* this carefully wrought immediacy, like a precisely tuned piano wire, keeps the work at a high pitch of intensity, an intensity that is as subtle as it is powerful.

For Clemmer an important means of communicating his experience to the viewer is geometry. In *Road to Voukari/Kea,* we see the familiar tripartite division of the canvas. The beholder finds his or her place stabilized by the same geometry, facilitating the transferral of experience between artist and viewer. As in other landscapes, Clemmer further divides his canvas horizontally. In some works this is done with the simple, thin, dark lines we have seen in so many images. Here, however, Clemmer uses the point of contact between water and land to create that line across the left two-thirds of the canvas. In allowing the forms of nature to perform the same function as his own artistic device, Clemmer suggests that the geometry we create is continuous with that of nature, that artist/viewer and natural scene are united within an overarching mathematical framework.

Yet this re-connecting of the viewer to the natural world is neither sentimental nor explicit. In one of his most sophisticated landscapes, *San G. II* (1993, cat. 47), Clemmer abbreviates the name of the city, making the title as economical as the painted notation of the hill town. This is brevity in the service of irony, as the artist chooses a location that has passed from revered monument to aes-

thetic cliché, thanks to generations of landscapists and busloads of tourists, only to be rescued and returned to us as a new experience. Part of the complexity of reference lies in Clemmer's handling of his medium. On the one hand, he chooses oil on canvas, the hallowed vehicle for the landscape tradition in the eighteenth and nineteenth centuries, but on the other he does not exploit that medium by building up predictable impasto or working the surface wet-in-wet. In his hands the towers of San Gimignano — that pretext for demonstrating a command of Albertian one-point perspective — are rendered with a quality so flat that the medium could be misread as acrylic. Still, on the level of painterly facture, such postmodern appropriation again is visible in passages whose illusion of delicate transparency connotes that other staple of the landscapist's palette, watercolor. As is characteristic of Clemmer's handling, however, these passages are tours-de-force of such subtlety that their absolute control is matched only by their abstracting brevity.

This interest in the connection between the spiritual life of humanity and the physical and metaphysical universe has informed Clemmer's work throughout his career, even though the language in which it has been expressed has changed. Reviving the traditional role of art as a path to spirituality, in a time that has witnessed drastic dislocation of the individual's connection to the world around him or her, Clemmer has turned to art as a means of reintegrating the self with the universe. In this way, he remains very much the heir to a period of time when that connection seemed to have been severed radically. If, as a result, Clemmer's focus has continued to be the search for a bridge over the chasm that separates the individual from the cosmos, his means of approaching that solution have ceaselessly evolved over six decades of uninterrupted artistic production. Clemmer's career has been an ongoing pursuit of the language of paint, geometry, form, and abstraction — a language that will be both specific and understandable as well as universal and all-encompassing.

FOOTNOTES

Acknowledgement: We would like to thank E. John Bullard and William A. Fagaly for their generous assistance, and their exceptional hospitality, as we prepared this essay; Emma Haas also smoothed many practical details. By sharing his notes on his father's biography, David Clemmer made the exchange of information natural. Margarita Gleba and Sarah Kielt both provided valuable feedback during the early stages of the manuscript. Dottie Clemmer has been admirably organized, making our work easier at every turn and responding to our queries with sensitivity and accuracy. Above all the opportunity for an intimate acquaintance with John Clemmer's works, and the experience of seeing them with the artist alongside as our private guide, has been both a pleasure and a memorable privilege.

1. For instance, the recent show at the Museum of Modern Art in New York (Kirk Varnedoe, *Jackson Pollock*, New York: Museum of Modern Art, (exhibition catalogue), 1998).

2. According to the artist, the title of the painting comes from Oscar Wilde's "Ballad of Reading Gaol." ("This too I know— and wise it were—If each could know the same-/That every prison that men build/Is built with bricks of shame/And bound with bars lest Christ should see/How men their brothers maim." In *Poems by Oscar Wilde, With the Ballad of Reading Gaol*, London: Methuen & Co., Ltd., 1927: 298.)

3. Alberta Collier, *The New Orleans Times-Picayune*, November 5, 1961, Section 2: 4.

4. Judith Bonner, "John Clemmer's Classical Order," *New Orleans Art Review*, v. XII, no. 2 (November/December 1993): 17.

5. Conversation with the artist, March 1999.

6. See Lucy Lippard, *Pop Art*, New York: Oxford University Press, 1966 and Russell Ferguson, ed., *Hand-painted Pop: American Art in Transition, 1955-62*, Los Angeles: Museum of Contemporary Art; New York: Rizzoli International Publications, (exhibition catalogue), 1992.

7. Robert Goodnough, "Jackson Pollock Paints a Picture," *ArtNews*, 50, no. 3 (May 1951): 60.

8. Anna Chave, *Mark Rothko: Subjects in Abstraction*, New Haven: Yale University Press, 1989: 136-39.

9. Pepe Karmel, "Pollock at Work: The Films and Photographs of Hans Namuth," in Varnedoe, 107-09.

10. Lake Douglas, "Ninas Holds Key to City's Vibrant Art History," *Lagniappe*, October 23, 1998: 16. According to Clemmer also, Ninas was the central figure at the Arts and Crafts Club in the French Quarter during the 1930s and 1940s. The Arts and Crafts Club was the site of many exhibitions of modern art and was the chief point of contact for Clemmer with modernist and abstract European art. (Artist in conversation with David Clemmer, September 1998.)

11. Conversation with the artist, November 1998.

12. Sarah Whitfield, "Fragments of an Ideal World," in John Elderfield and Sarah Whitfield, eds., *Bonnard*, (exhibition catalogue), New York: Harry N. Abrams Publishers, Inc., (exhibition catalogue), 1998: 24.

13. See Gerald Nordland, "The Figurative Works of Richard Diebenkorn" in, *Richard Diebenkorn: Paintings and Drawings, 1943-76*, Buffalo, NY: Albright-Knox Art Gallery, (exhibition catalogue), 1976: 40-41.

14. Clemmer's religious work includes sculptures such as *Pentateuch*, 1979-81 at the Tikvat Shalom Conservative Congregation in New Orleans, *Burning Bush* (Ner Tamid), 1979-81 at Congregation Temple Sinai in New Orleans and the pattern for *Design–Ark Tapestry*, 1977-81 also at the Temple Sinai. In that all are concerned with spirituality there is no real break between these works and those in this exhibition. The artist has, in fact, found the work of the contemporary Jewish philosopher Abraham Joshua Heschel deeply influential, both on his life and his work. Heschel, who was concerned with the position of faith in the modern world, wrote, in a phrase that seems to mirror Clemmer's attitude as an artist before the world, "Our certainty is the result of wonder and radical amazement, of awe before the mystery and meaning of the totality of life beyond our rational discerning." (Fritz A. Rothschild, ed., *Between God and Man: An Interpretation of Judaism from the Writings of Abraham Joshua Heschel*, New York: Free Press Paperbacks, 1959: 65). Clemmer reads from this volume every day as he eats lunch in his studio and when he finishes the book he begins again. (Conversation with the artist, March 1999.)

15. Before the twentieth century of course, art often functioned both to communicate and facilitate intense human feeling, often in close connection with religion. Most importantly, images have often served as a means by which the individual could locate him-or herself within a cosmos that extended beyond the visible world. Throughout the early Christian and Middle Ages, in both Western and Eastern Christianity, images were key aspects of doctrinal instruction. In the sixth century B.C., for instance, Bishop Hypatios of Ephesus placed pictures within a Neo-Platonic framework of the hierarchy of essences that connected God to Creation. Hypatios asserted that images could instruct the faithful in that hierarchy, by suggesting the invisible, God, in visible

form. (Leslie Barnard, "The Theology of Images," in Anthony Bryer and Judith Herrin, eds. *Iconoclasm: Papers Given at the Ninth Spring Symposium of Byzantine Studies,* University of Birmingham, March 1975, Birmingham: Centre for Byzantine Studies, 1977: 11.) In this case, art becomes not only a means of instruction in the didactic sense, but it also conveys a picture of the spiritual world to the viewer. Images provide a framework into which the viewer may place him or herself in relation to the divine essence and, of course, the church, which becomes the arbiter of that divine essence.

16. Sherry A. Buckberrough, *Robert Delaunay: The Discovery of Simultaneity,* Ann Arbor, MI: UMI Research Press, 1982: xxi.

17. Buckberrough, 133-35.

18. It is interesting to note that in this case, as in many others, Clemmer conceives of his drawing as a work of art complete unto itself and independent of the painting, rather than as a preparatory study. (Conversation with the artist, March 1999.)

19. See C. L. Wysuph, *Jackson Pollock Psychoanalytical Drawings,* New York: Horizon Press, 1970.

20. Other Abstract Expressionists such as Adolph Gottlieb, Mark Rothko, and Barnett Newman, explored mythic and tribal imagery and sought to connect their art with the primitive artists, again stressing the expression of the psychological state of the individual in a hostile world. Gottlieb said in 1943: "If we profess kinship to the art of primitive man, it is because the feelings they expressed have a particular pertinence today.... All primitive expression reveals the constant awareness of powerful forces, the immediate presence of terror and fear, a recognition of the brutality of the natural world and the eternal insecurities of life. That these feelings are being expressed by many people today is an unfortunate fact, and to us an art that glosses over or evades these feelings is superficial and meaningless. That is why we insist on subject matter, a subject matter that embraces these feelings and permits them to be expressed." (Adolph Gottlieb and Mark Rothko, "The Portrait and the Modern Artist," radio broadcast, October 13, 1943, WNYC. Reprinted in *Adolph Gottlieb: A Retrospective,* New York: Arts Publishers, 1981: 171.)

21. Donald G. Baker and Charles Sheldon, *Postwar America: the Search for Identity,* Beverly Hills: The Glencoe Press, 1969: 2.

22. Eric and Mary Josephson, *Man Alone: Alienation in Modern Society,* New York: Dell Publishing, 1962: 9-53.

23. The question of the connection between Abstract Expressionism and a loss of individual subjectivity has been most thoroughly explored by Michael Leja (*Reframing Abstract Expressionism: Subjectivity and Painting in the 1940s,* New Haven: Yale University Press, 1993). Leja connects the work of the Abstract Expressionists to other cultural forms of the 1950s, such as the film noir genre and suggests that they share a common concern, namely the loss, due to such factors as those described above, of individual subjectivity in the modern world. Their artistic process, Leja asserts, can be understood in terms of what he calls a "Modern Man Discourse," a broad cultural expression of concern over this loss. In making this argument, Leja is building on an increasing body of work by art historians interested in elucidating the subject of Abstract Expressionism, as opposed to the purely formal terms in which it had been largely discussed until the 1970s. See, for example, Thomas B. Hess, *Barnett Newman,* New York: Museum of Modern Art, (exhibition catalogue), 1979, Barbara Cavaliere and Robert Hobbs, "Against a Newer Laocoon," *Arts,* April 1977, E. A. Carmean and Eliza Rathbone, with Thomas B. Hess, *American Art at Mid-Century: The Subjects of the Artist,* Washington: DC: National Gallery of Art, (exhibition catalogue), 1978, and Chave, 1989. Our discussion of John Clemmer is indebted to Leja's work and in some ways our argument is similar. Nonetheless, Leja's attempt is to critique the Abstract Expressionists and to suggest that they, along with others, were attempting to reestablish the lost dominance of the individual white male by refiguring the concept of subjectivity. A number of similarities may be found between John Clemmer and Abstract Expressionists such as Mark Rothko. (Clemmer knew Rothko, in fact, when the latter taught in New Orleans at Newcomb College in 1957. See James Breslin, *Mark Rothko: A Biography,* Chicago and London: University of Chicago Press, 1993: 353-55.) But there are many differences as well. As convincing as Leja's argument is, the same case cannot be made about Clemmer, whose practice and goals are quite distinct from those of the Abstract Expressionists. Some of these differences will be discussed below.

24. Beginning in the late 1940s and continuing for many years, Clemmer painted Mardi Gras masks for a number of Carnival organizations.

25. Thinking perhaps of the kind of merger of figure and ground that is so prominent in *Portrait—Charles Bowen,* the artist recently said, "I like to do portraits where the total canvas is infused with what you're trying to express. The forms that are

there are not just anonymous forms—the color, the whole composition should express something of the person." (Artist in conversation with David Clemmer, September 1998.)

26. William Barrett, *Irrational Man: A Study in Existential Philosophy,* Garden City, NY: Doubleday Anchor, 1958: 21.

27. To suggest that some element of spirituality, as distinct from religion, remained an important aspect of painting in this period, as it had been for painters like Delaunay, Kandinsky, and Piet Mondrian before, it is perhaps useful to invoke the comments of the influential painter and teacher, Hans Hofmann, who, in 1948, made just such a distinction between spirituality and religion. Hofmann defined spirituality as "the emotional and intellectual synthesis of relationships perceived, rationally or intuitively. Spirituality in an artistic sense should not be confused with religion." (B. T. Hayes and S. T. Weeks, eds., *The Search for the Real and Other Essays by Hans Hofmann,* trans. by Glenn Wessels, Andover, MA: Addison Gallery of American Art, 1948: 72.)

28. This idea was particularly prevalent in Renaissance architecture. See Rudolf Wittkower, *Architectural Principles in the Age of Humanism,* New York: W. W. Norton, 1971: 27-32.

29. William L. McDonald, *The Pantheon: Design, Meaning and Progeny,* Cambridge, MA: Harvard University Press, 1976: 68-70. Clemmer would be well aware of this history of thought in architectural theory, having taught design in the Tulane School of Architecture from 1951 until 1978. He was chair of the art department at Tulane from 1978 to 1986.

30. Galileo Galilei, "The Assayer," in *The Controversy of the Comets of 1618,* trans. by Stillman Drake and C. D. O' Malley, Philadelphia: University of Pennsylvania Press, 1960: 183-4.

31. John Clemmer, *Louisiana State University—Alexandria* (exhibition catalogue), 1971: unpaginated.

32. Kurt Weitzmann, "The Selection of Texts for Cyclical Illumination in Byzantine Manuscripts," in *Byzantine Book Illumination and Ivories,* London: Varorium Reprints, 1980: 6.

33. In conversation the artist suggested, in fact, that the tri-partite division of the canvas appeared in his work as early as the 1950s, in a painting no longer extant.

34. Mark Rothko also used the triptych format, in his paintings at the Rothko Chapel in Houston. See Sheldon Nodelman, *The Rothko Chapel Paintings: Origins, Structure, Meaning,* Austin: University of Texas Press, 1997.

35. John Clemmer, *Louisiana State University—Alexandria* (exhibition catalogue), 1971: unpaginated.

36. Ibid. Whether in the timelessness of *Topographia I—Cosmas I,* which deliberately elides any specific reference to place, or in the very specifically located *Topographia III—Guatemala,* there is an effort to image the universal. From the 1970s forward, this representation of abstracted, universalized, and yet frequently very particularized landscapes continues: *Wahgouly Portal* of 1977, the watercolor and gouache *Landscape* of 1977, the *Portal—Itea* (1978), *Portal—Festive* (1979), *Journey to Torcello* (1981), *Journey to Murano* (1982), *Tangipahoa* (1982), the two *San Gimignano's, I and II* of 1991 and 1993, *Murano I* (1992), *Temple of Poseidon* (1992), *Road to Voukari* (1992), *Birches—Duo* (1996), *Through the Woods* (1997) and *View—Wahgouly I* (1998) testify with an ongoing involvement with the issue of locales. It is no accident that the *Triunity* series, for example *Triunity I,* and *Triunity V,* 1995 and 1997-99, not only fall chronologically within this sequence, but look very much like these images of a faceted and conceptualized Nature.

37. Norma Broude, *Impressionism: A Feminist Reading: The Gendering of Art, Science, and Nature in the Nineteenth Century,* New York: Rizzoli, 1991: 31-33.

38. R. B. Beckett, ed., *John Constable's Correspondence,* 6 vols., Ipswich: Suffolk Records Society, vol. 6: 78.

39. Conversation with the artist, November 1998.

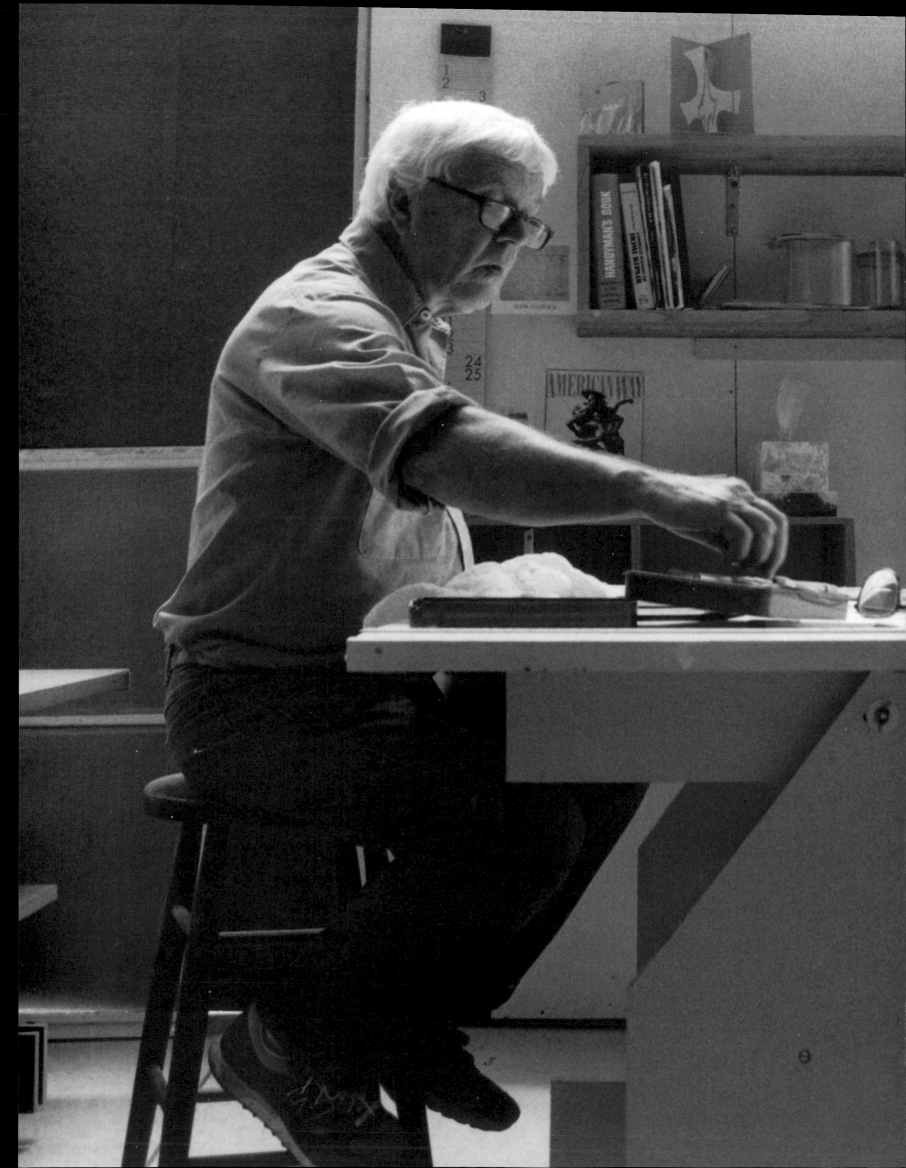

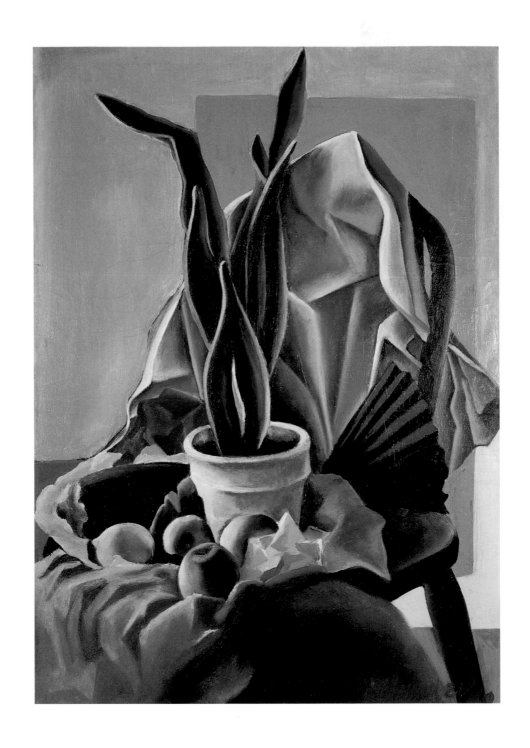

1. STILL LIFE, 1940 Oil on canvas, 35 x 24 inches

Collection of the Artist, New Orleans, Louisiana

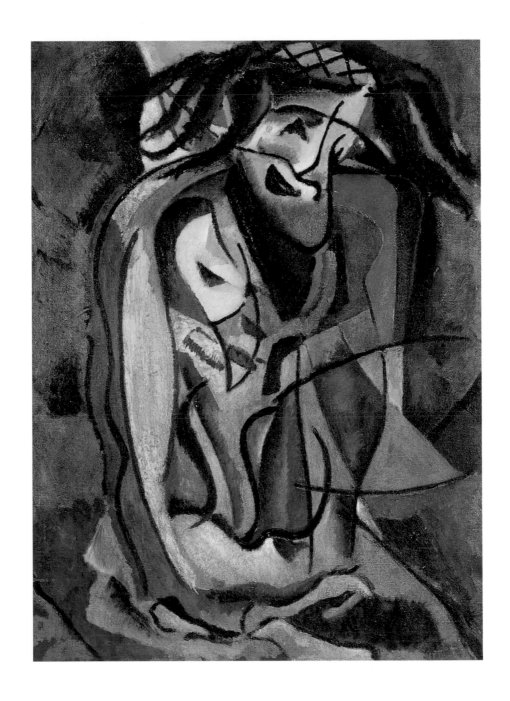

2. "HOW MEN THEIR BROTHERS MAIM," 1942 Oil on canvas, 35 x 26 inches

Collection of Edwin Lupberger, New Orleans, Louisiana

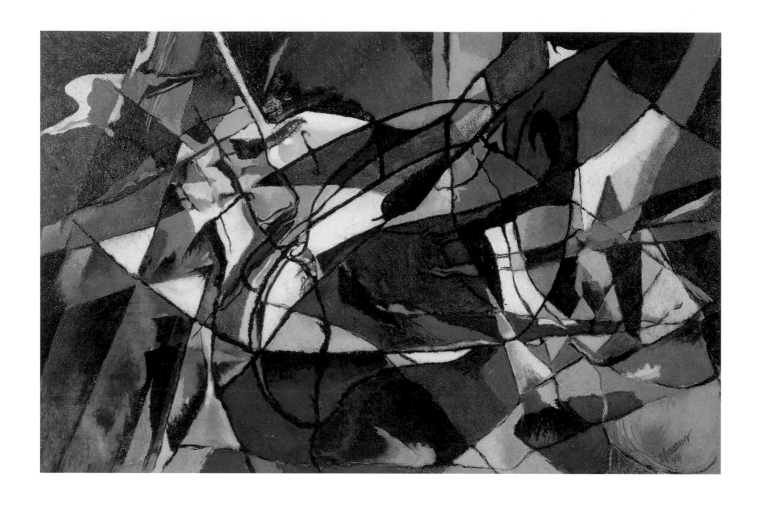

3. SEE UNGEHEUER, 1944 Oil on panel, 24 x 36 inches

Collection of Herbert Halpern and Jacqueline Bishop, New Orleans, Louisiana

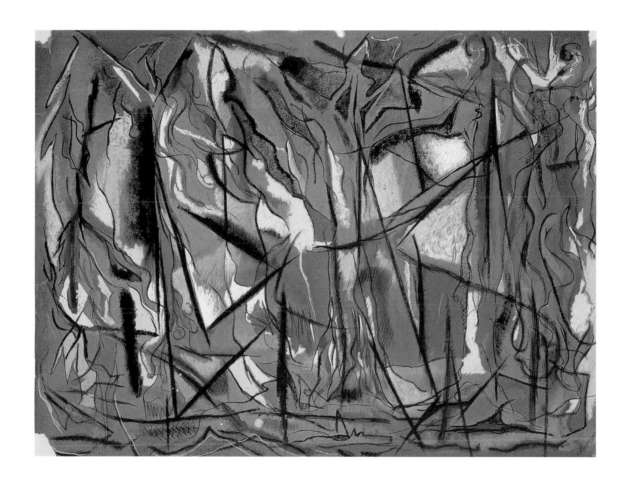

4. SWAMP FIRE, 1947 Watercolor, gouache on paper, 18 x 24 inches
Collection of the Artist, New Orleans, Louisiana

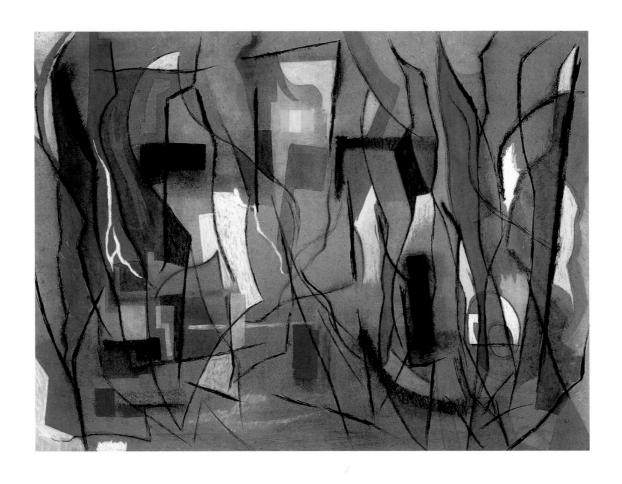

5. CONSEQUENCES OF MORNING, 1947 Watercolor, gouache on oatmeal paper, 18 x 24 inches
Collection of Mari Newman Colie and Stuart Colie, Ocean Springs, Mississippi

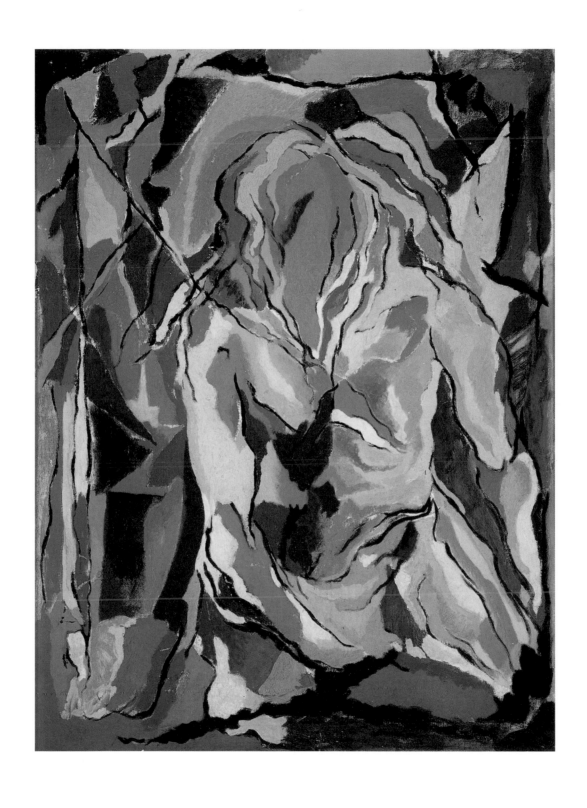

6. KNEELING NUDE, 1949 Oil on canvas, 40 x 30 inches

Collection of the Artist, New Orleans, Louisiana

7. TWO FIGURES—MACBETH, 1949 Oil on canvas, 60 x 40½ inches
Collection of the New Orleans Museum of Art, Gift of David Clemmer. 97.822

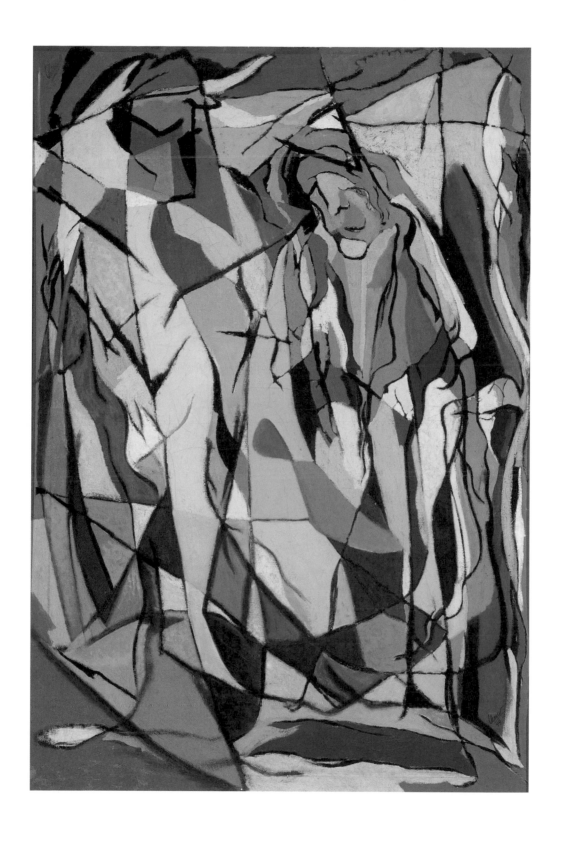

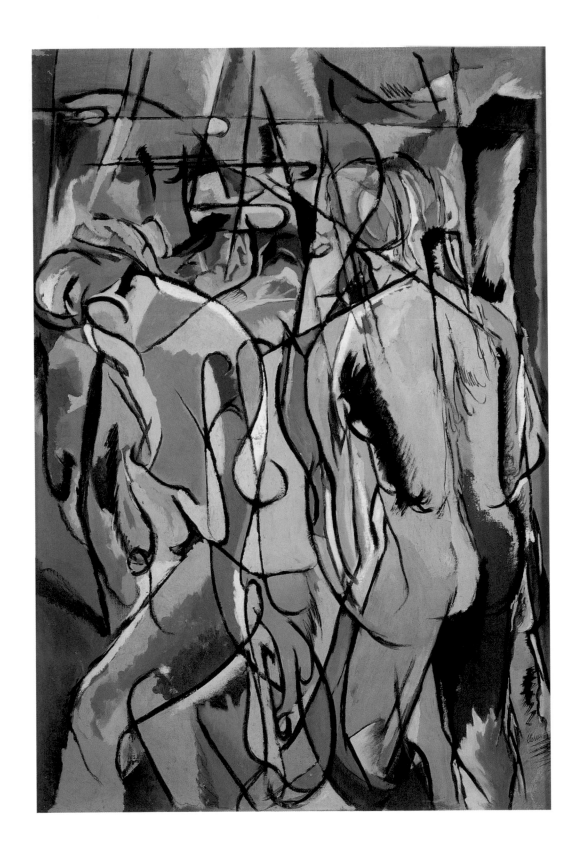

8. TWO NUDES IN A LANDSCAPE, 1949 Oil on canvas, 50 x 34 inches

Collection of the Artist, New Orleans, Louisiana

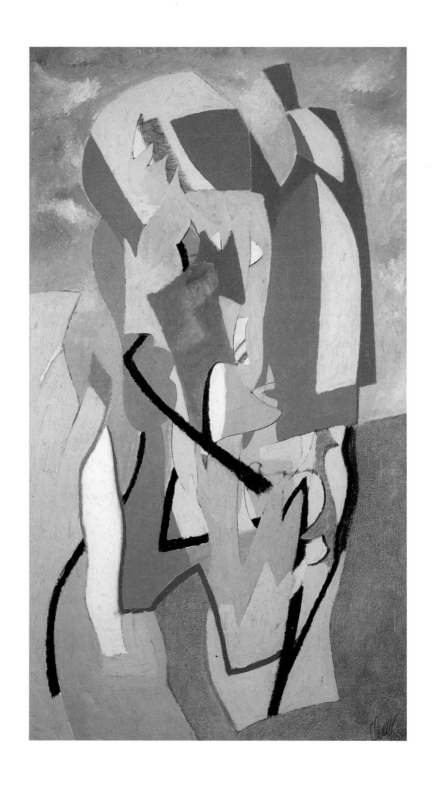

9. NOON VISIT, 1950 Oil on canvas, 38 x 21 inches

Collection of the Artist, New Orleans, Louisiana

10. PORTRAIT—CHARLES BOWEN, 1950 Oil on canvas, 40 x 24 inches

Collection of Mr. and Mrs. Charles Bowen, Stamford, Connecticut

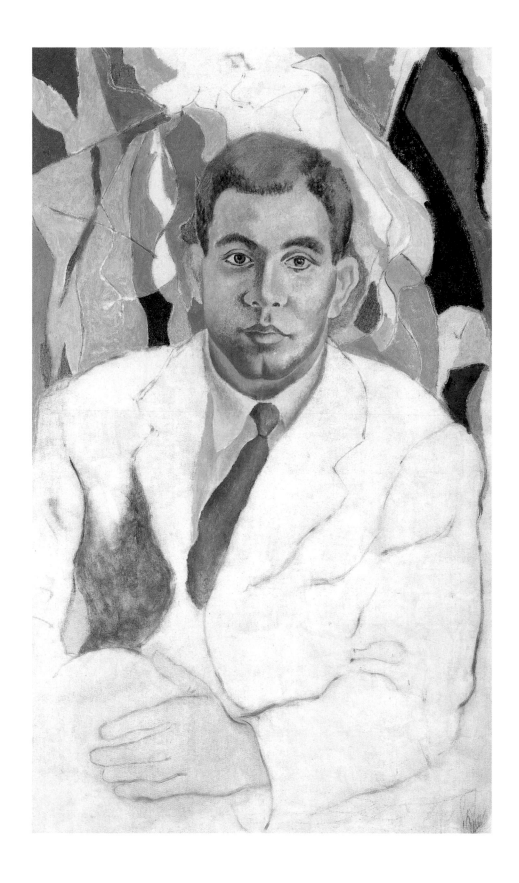

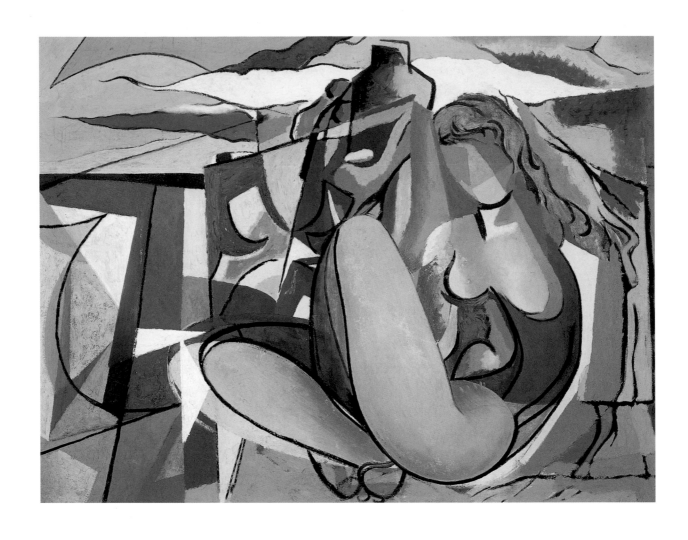

11. NUDE WITH STILL LIFE, 1951 Oil on canvas, 36 x 48 inches

Collection of the Artist, New Orleans, Louisiana

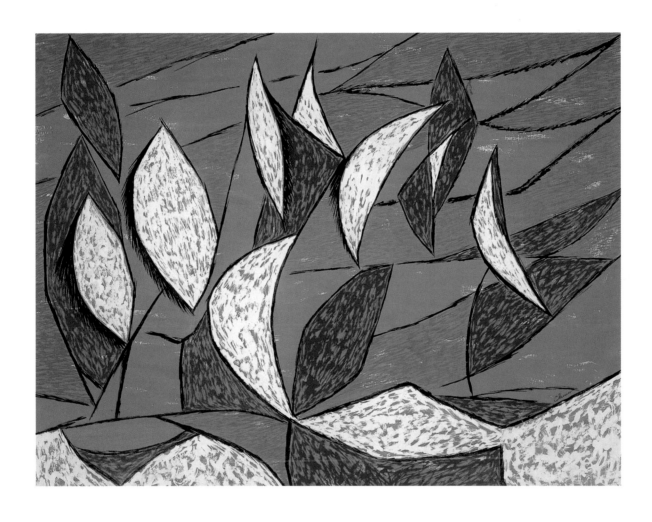

12. WINDSWEPT, 1952 Casein on paper, 20 x 26 inches

Collection of the Artist, New Orleans, Louisiana

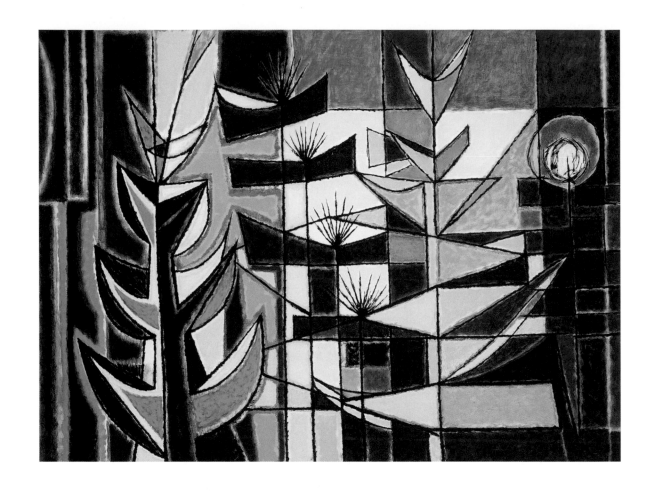

13 FLORAL/VERTICAL, 1950s Oil on board, 24 x 32 inches

Collection of the Artist, New Orleans, Louisiana

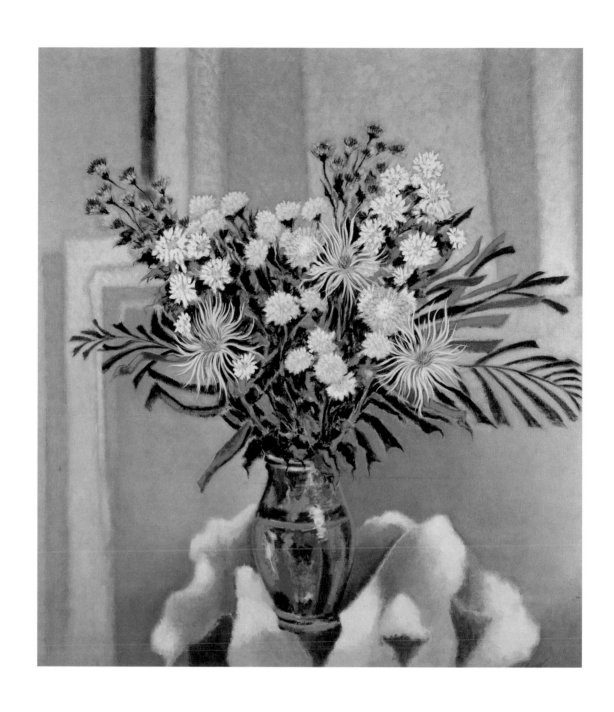

14. BLUE VASE, 1955 Oil on canvas, 42 x 37 inches

Collection of the New Orleans Museum of Art, Gift of Judith and Robert Stein. 96.239

15. MARCH, 1962 Oil on unprimed linen, 54¹/₄ x 56 inches

Collection of Mrs. F. Monroe Labouisse Jr., New Orleans, Louisiana

16. VERTICAL VIEW, 1959 Charcoal, oil on canvas, 60 x 24 inches

Collection of the Artist, New Orleans, Louisiana

17. SALEM SYMBOL, 1966 Oil on panel, 48 x 48 inches
Collection of Mr. and Mrs. Victor Bruno, New Orleans, Louisiana

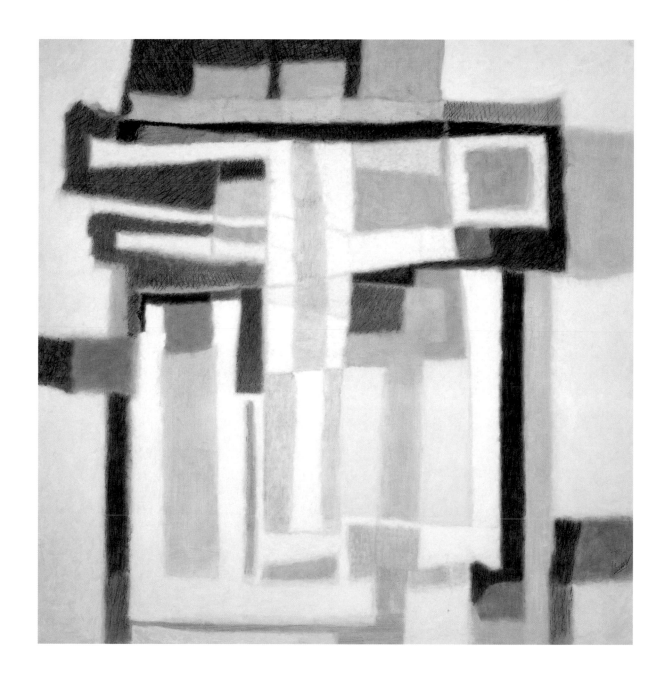

18. PORTRAIT—WING MACDONALD (FLORENCE MAY MACDONALD), 1961-62

Oil on canvas, 48 x 36 inches

Collection of Florence and John Boogaerts, Cos Cob, Connecticut

19. ALMEDIA, 1962 Collage, oil on panel, 72 x 48 inches
Collection of David Clemmer, Santa Fe, New Mexico

20. NARANJA, 1963 Oil on board, 48 x 48 inches

Collection of Gary and William A. Baker, New Orleans, Louisiana

21. PORTRAIT—LIN EMERY AND SHIRLEY BRASELMAN, 1967-68 Oil on canvas, 60 x 50 inches

Collection of Lin Emery and Shirley Braselman, New Orleans, Louisiana

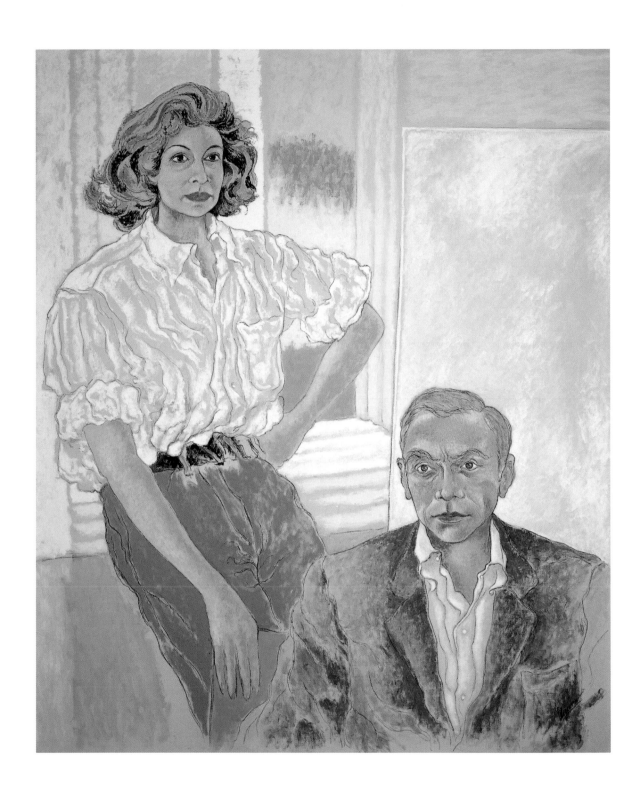

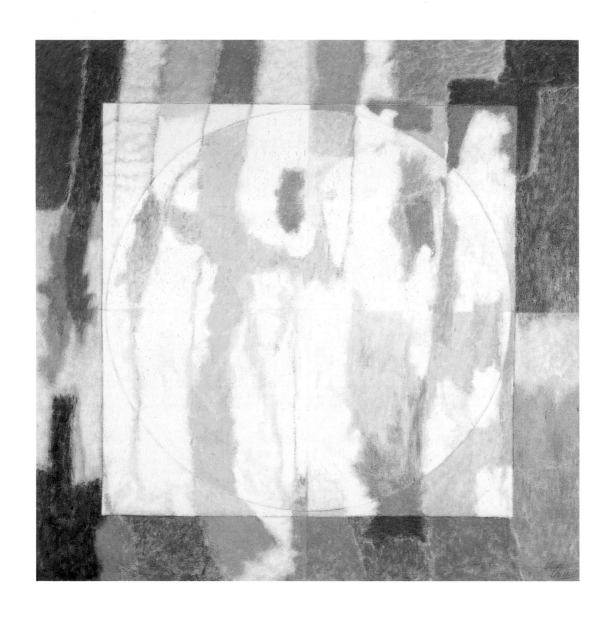

22. TOPOGRAPHIA I—COSMAS I, 1969-70 Mixed media on canvas, 48 x 48 inches
Private Collection, Washington, D. C.

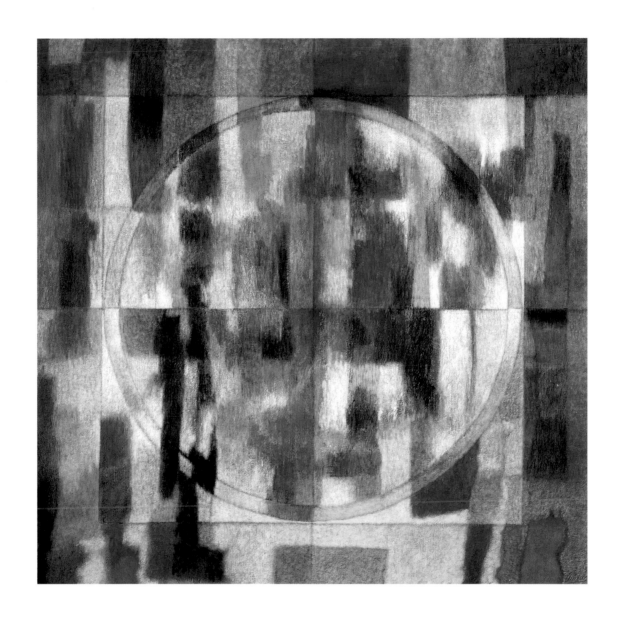

23. TOPOGRAPHIA II—ATITLAN, 1969 Mixed media on canvas, 48 x 48 inches

Collection of the School of Architecture, Tulane University, New Orleans, Louisiana

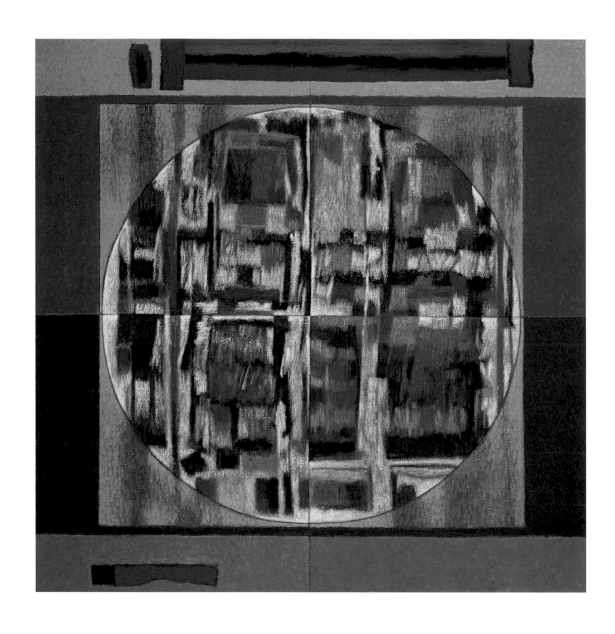

24. TOPOGRAPHIA III—GUATEMALA, 1969-70 Mixed media on canvas, 48 x 48 inches

Collection of the Honorable and Mrs. Martin L. C. Feldman, New Orleans, Louisiana

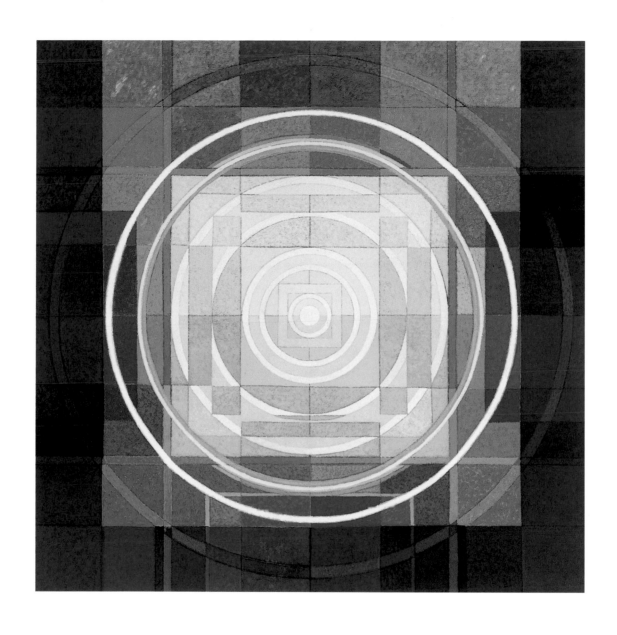

25. TOPOGRAPHIA IV—COSMAS II, 1970 Oil on canvas, 48 x 48 inches
Collection of the New Orleans Museum of Art, Gift of Jonathan Clemmer. 97.823

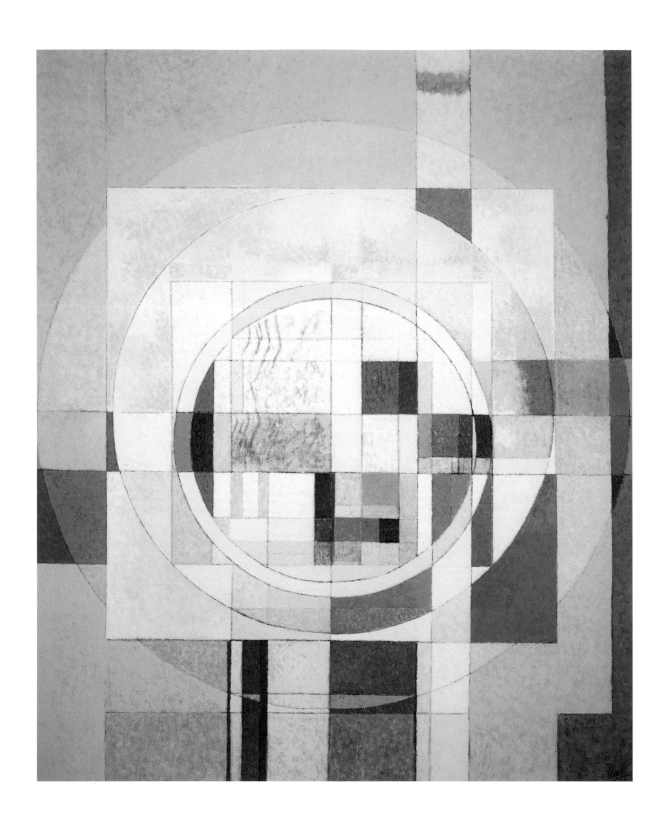

26. TOPOGRAPHIA V—CAPRICORN, 1973 Oil on canvas, 60 x 40 inches

Collection of Jonathan Clemmer, New York, New York

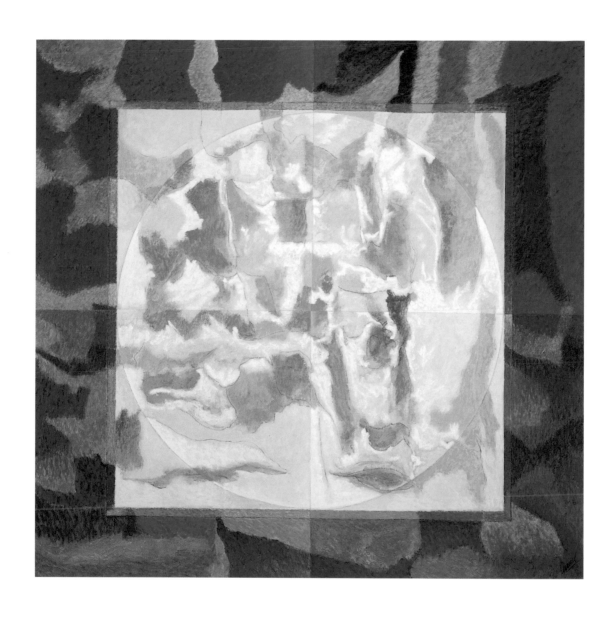

27. TOPOGRAPHIA VI—LUNA, 1969 Polymer, oil on canvas, 48 x 48 inches

Collection of the Artist, New Orleans, Louisiana

28. FLORAL—CIRCLES II, 1974 Oil on canvas, 60 x 24 inches
Collection of Margery and Charles Stich, New Orleans, Louisiana

66

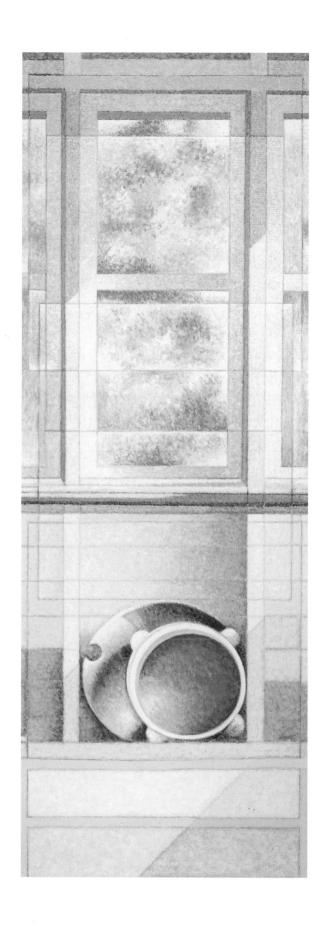

29. WAHGOULY PORTAL, 1977 Oil on canvas, 76 x 27¼ inches
Collection of BlueCross and BlueShield of Louisiana, Baton Rouge, Louisiana

30. LANDSCAPE, 1977 Watercolor, gouache, collage on oatmeal paper, 18 x 24 inches

Collection of David Clemmer, Santa Fe, New Mexico

31. PORTAL—FESTIVE, 1979 Watercolor, gouache on oatmeal paper, 18 x 24 inches

Collection of Mrs. Edmund McIlhenny, New Orleans, Louisiana

32. PORTAL—ITEA, 1978 Oil on canvas, 30 x 30 inches

Collection of the New Orleans Museum of Art, Muriel Bultman Francis Collection. 86.171

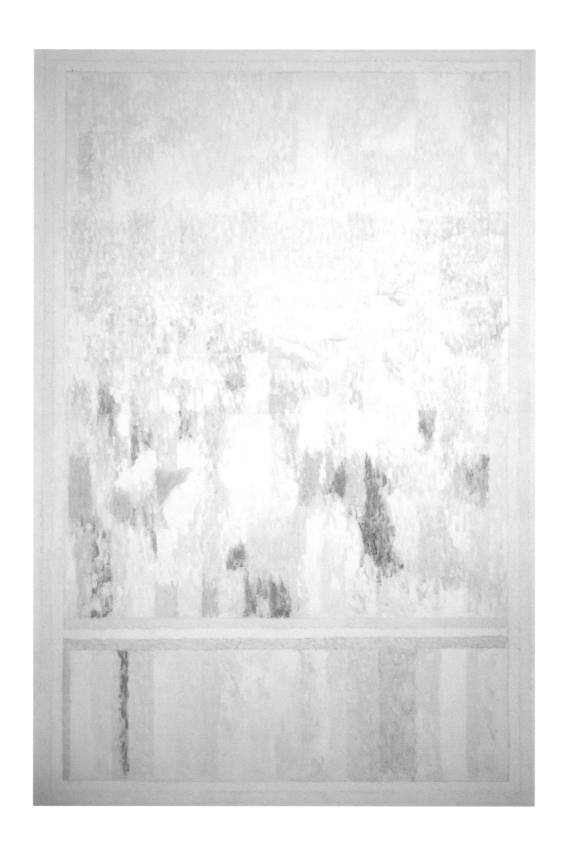

33. PORTAL—JUDEAN, 1977 Oil on panel, 60 x 48 inches

Collection of Mr. and Mrs. William A. Porteous, New Orleans, Louisiana

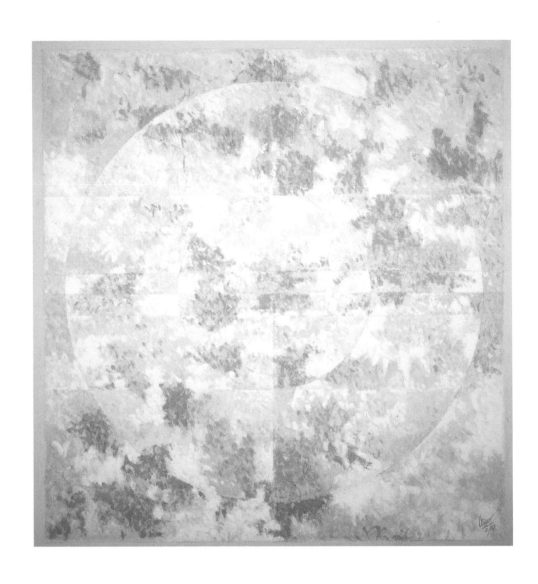

34. CIRCLE—SHIELDS, 1987 Oil on canvas, 38 x 36 inches

Collection of Lloyd N. Shields, New Orleans, Louisiana

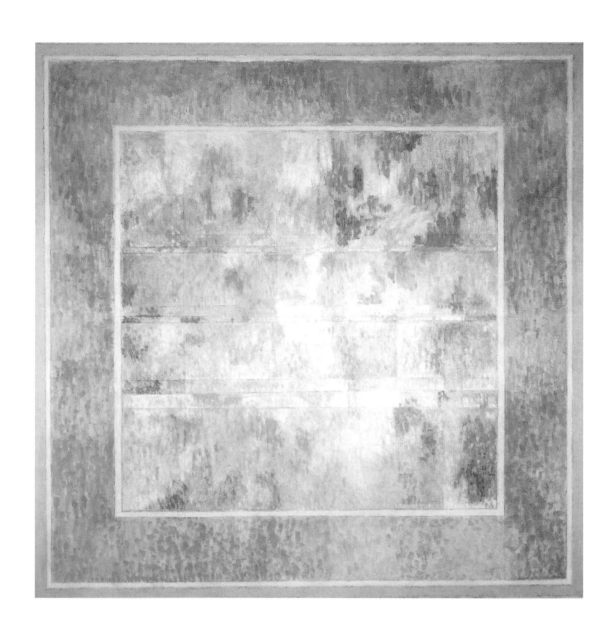

35. PORTAL—VIEW, 1980 Oil on canvas, 48 x 48 inches

Collection of Beverly and Lester Wainer, Metairie, Louisiana

36. JOURNEY TO TORCELLO, 1981 Mixed media on Strathmore, 36$^{1}/_{2}$ x 26$^{1}/_{2}$ inches

Collection of Julian and Peggy Good, New Orleans, Louisiana

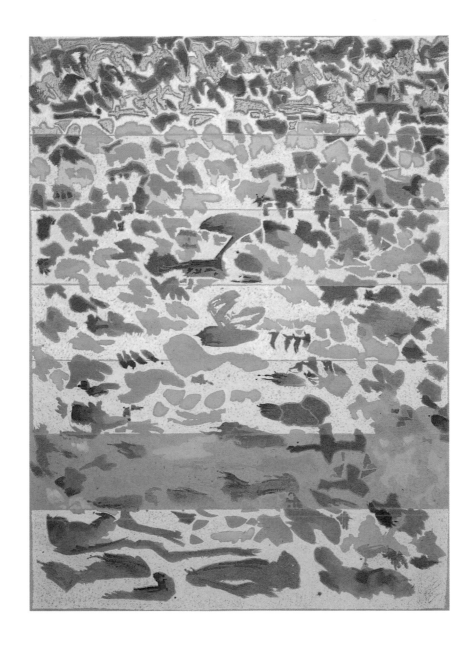

37. JOURNEY TO MURANO, 1982 Mixed media on Strathmore, 34 x 27 inches

Collection of Julian and Peggy Good, New Orleans, Louisiana

38. FLORAL IV, 1981 Oil on canvas, 61 x 27 inches

Collection of Bobby and Karen Major, New Orleans, Louisiana

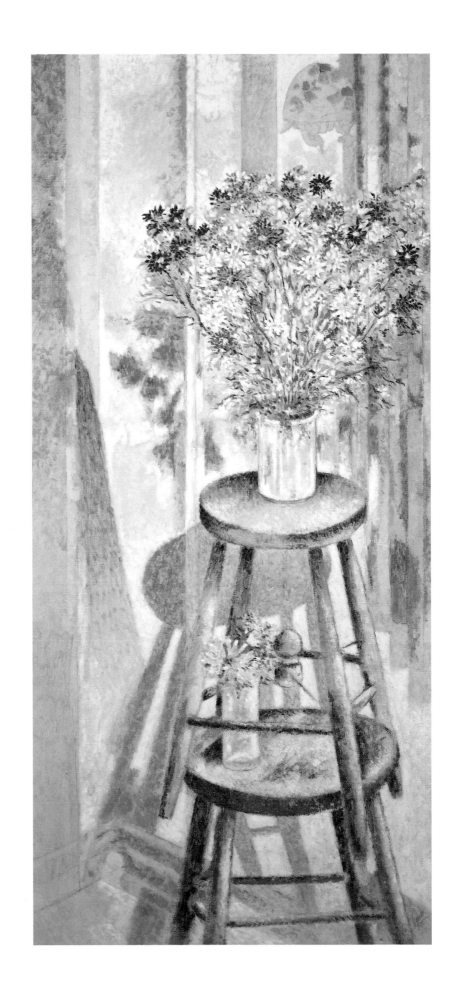

39. MURANO I, 1982 Oil on canvas, 26 x 24 inches
Private Collection, Houston, Texas

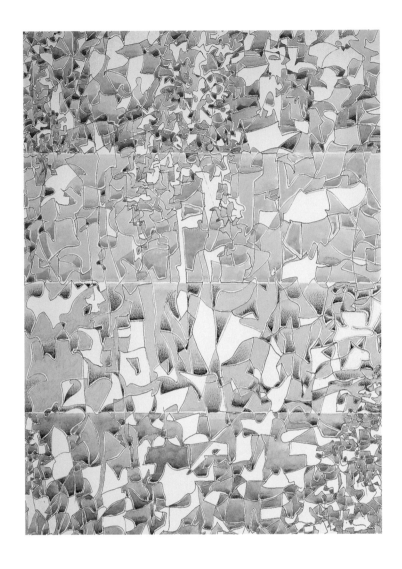

40. THE SEASONS, 1982 Watercolor on Bristol board, 18¹/₂ x 13¹/₂ inches

Collection of Dr. and Mrs. Eamon Kelly, New Orleans, Louisiana

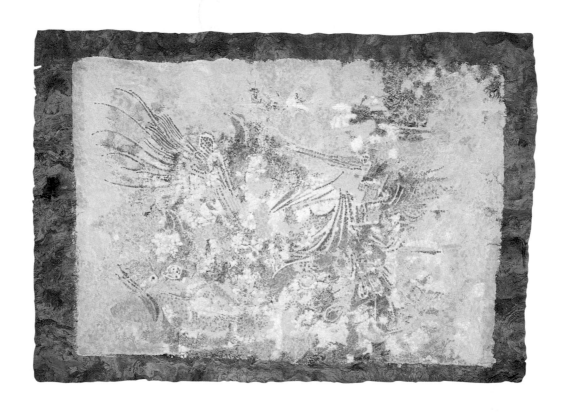

41. PLUMED, 1985 Mixed media on papel de amate, 17 x 24½ inches
Collection of the Artist, New Orleans, Louisiana

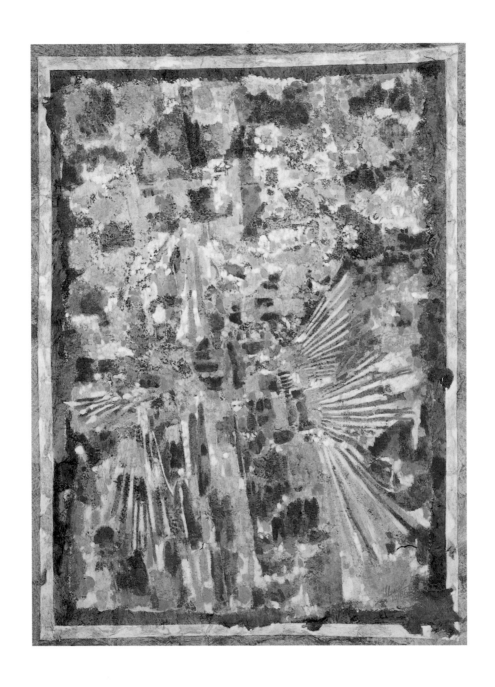

42. EXALTATION, 1987 Mixed media on papel de amate, 40 x 32¹/2 inches

Collection of Dr. Joseph D. Kirn, New Orleans, Louisiana

43. VAPIOS, 1987 Mixed media on papel de amate, $7^{3/4}$ x $23^{3/4}$ inches
Collection of Bobby and Karen Major, New Orleans, Louisiana

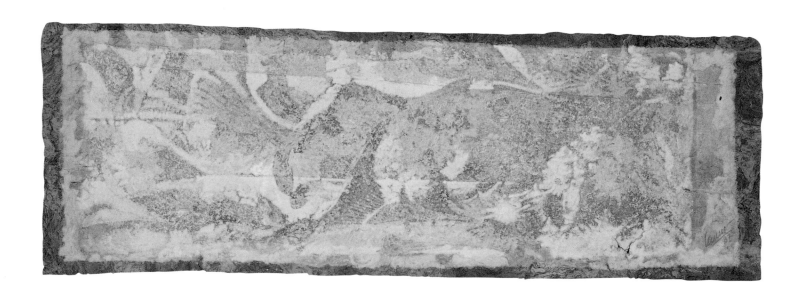

44. SCULPTURE, 1986 Bronze, nickel silver on monel, 120 x 30 inches
Collection of Rick and Martha Barnett, Tallahassee, Florida

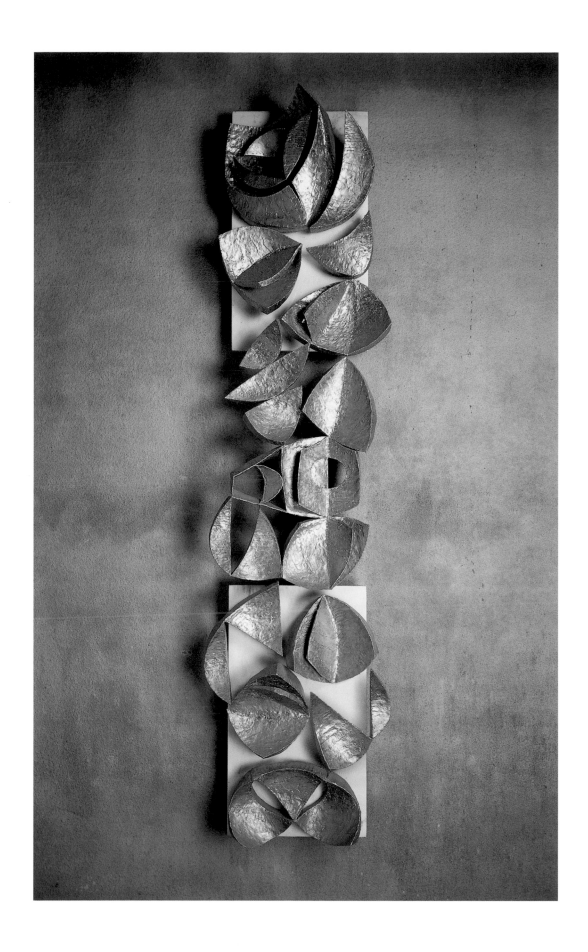

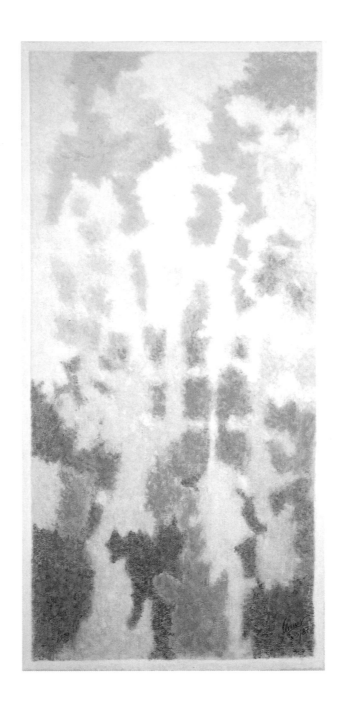

45. TANGIPAHOA, 1987 Oil on canvas, 44 x 22 inches
Collection of the Artist, New Orleans, Louisiana

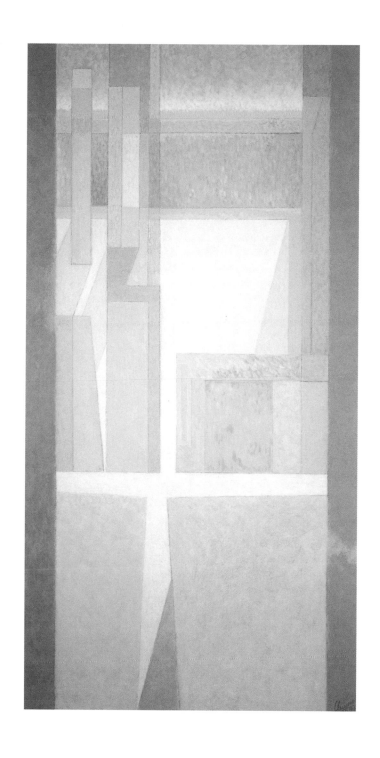

46. SAN G. I, 1991 Oil on canvas, 48 x 24 inches
Collection of Dr. and Mrs. Charles Smith III, New Orleans, Louisiana

47 SAN G. II, 1993 Oil on canvas, 72 x 36 inches
Collection of the Artist, New Orleans, Louisiana

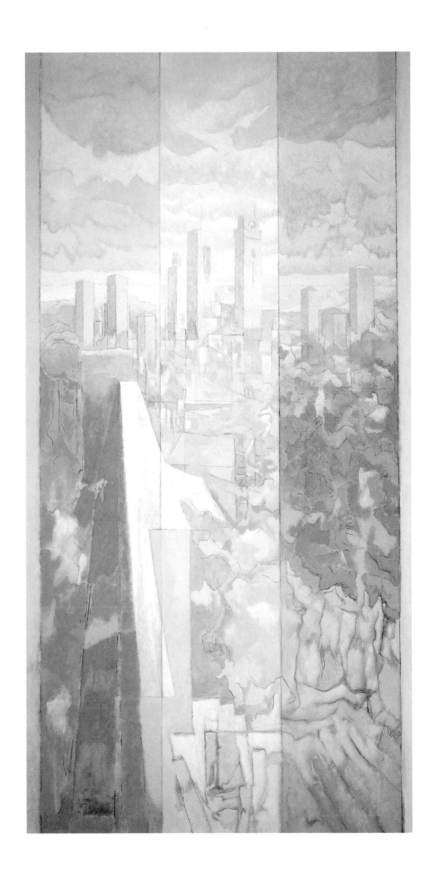

48. CORTONA/CREPUSCOLO, 1992 Mixed media on canvas, 54 x 60 inches
Collection of the Artist, New Orleans, Louisiana

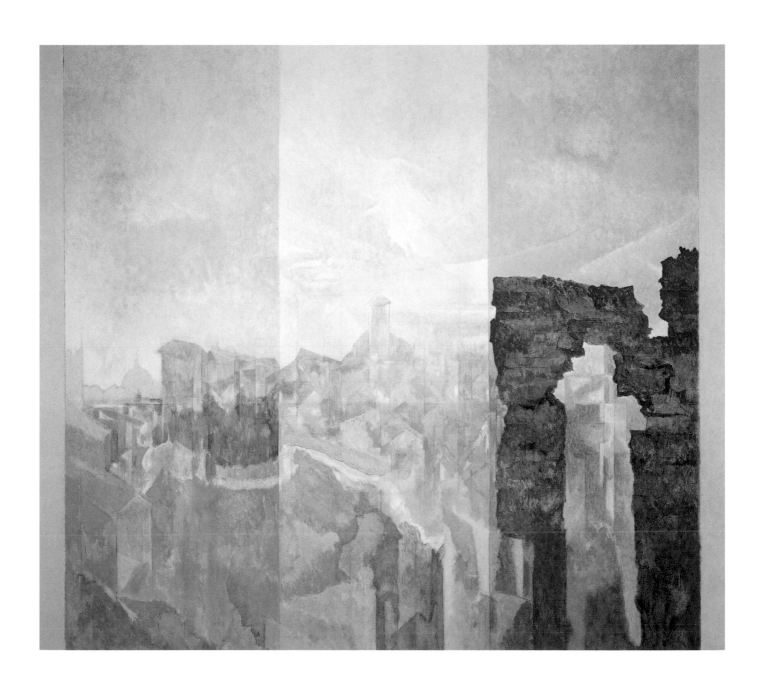

49 TRILOGY XIV, 1994 Oil crayon on Strathmore, 30 x 26 inches

Collection of the Artist, New Orleans, Louisiana

50. TRILOGY XVI, 1994 Oil crayon on Strathmore, 30 x 26 inches

Collection of the Artist, New Orleans, Louisiana

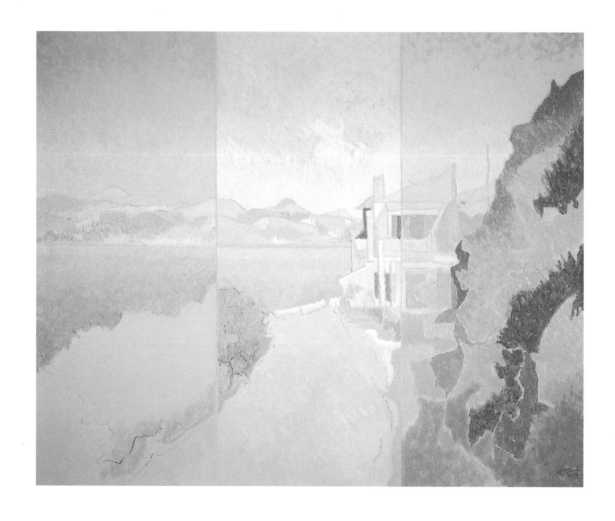

51. ROAD TO VOUKARI/KEA, 1992 Oil on canvas, 30 x 26 inches

Collection of Maestro James Paul, Baton Rouge, Louisiana

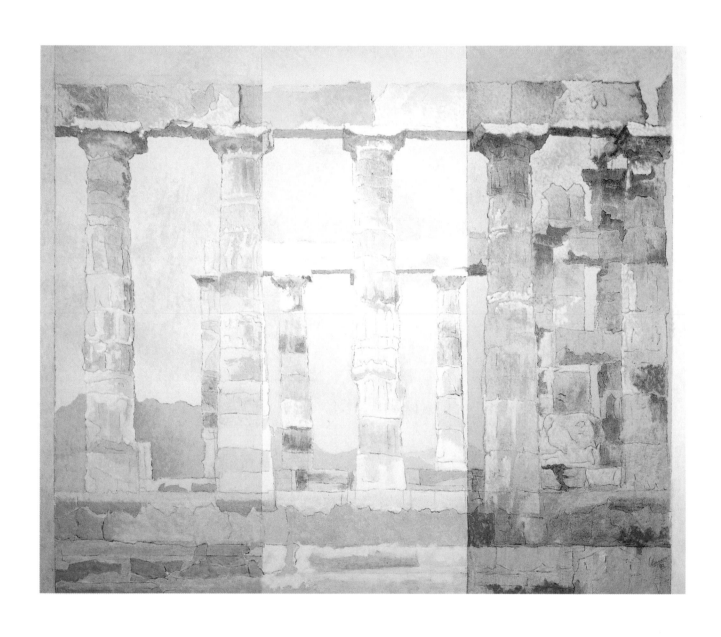

52. TEMPLE OF POSEIDON I, 1992 Mixed media on canvas, 50 x 60 inches

Collection of the Artist, New Orleans, Louisiana

53. TRIUNITY I, 1995 Mixed media on canvas, 56 x 45 inches
Collection of the New Orleans Museum of Art, Museum Purchase 97.126

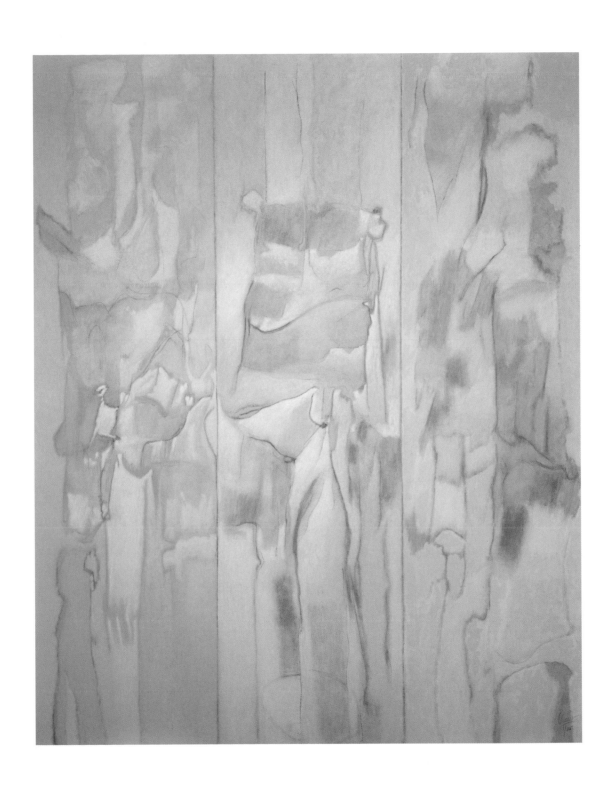

54. TRIUNITY V, 1997-99 Mixed media on canvas, 60 x 50 inches
Collection of the Artist, New Orleans, Louisiana

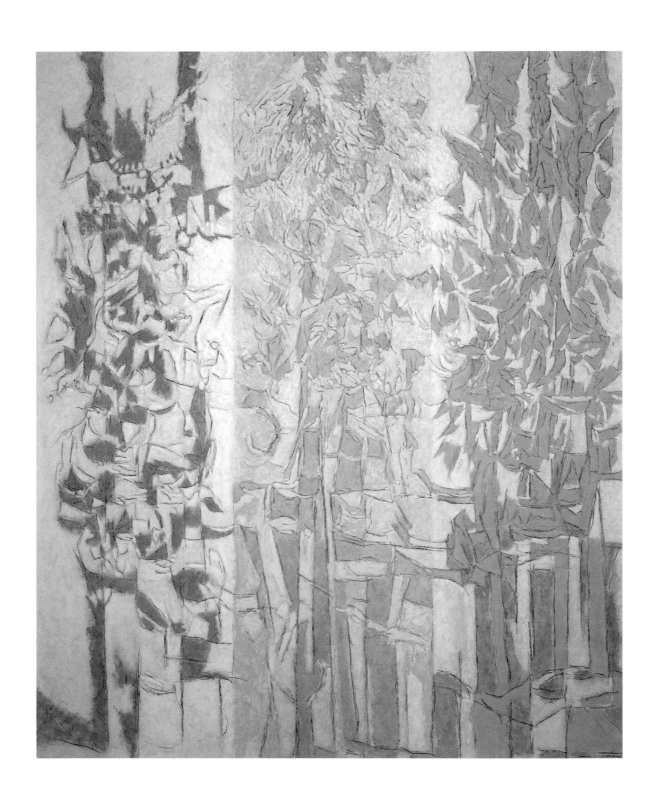

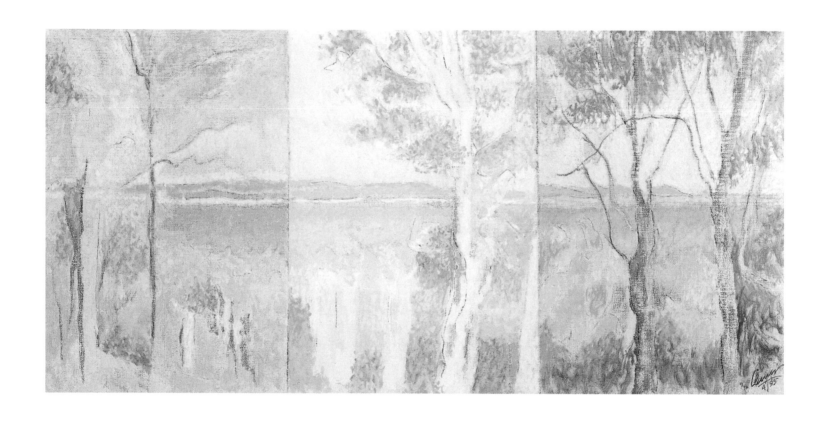

55. FROM THE COUNTRY HOUSE I, 1995 Oil on canvas, 11 x 22 inches

Collection of the Gerald Peters Gallery, Santa Fe, New Mexico

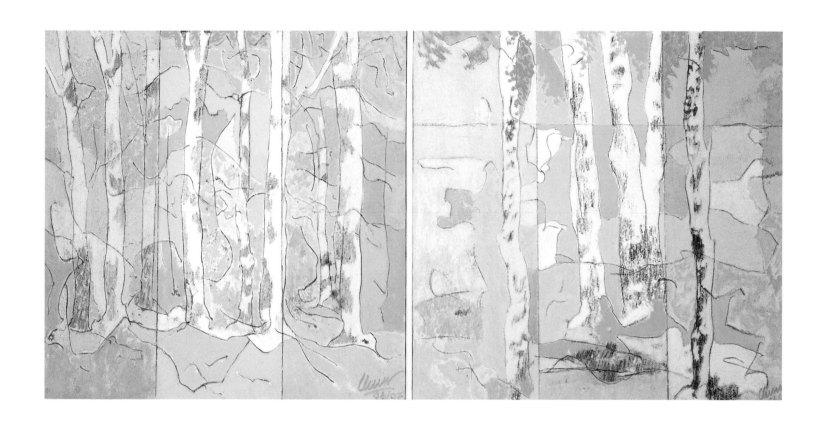

56 BIRCHES/DUO, 1996 Oil on board, 12 x 24 inches

Collection of the Artist, New Orleans, Louisiana

57. THROUGH THE WOODS, 1997 Mixed media on canvas, 60 x 48 inches

Collection of Burton Jablin, Knoxville, Tennessee

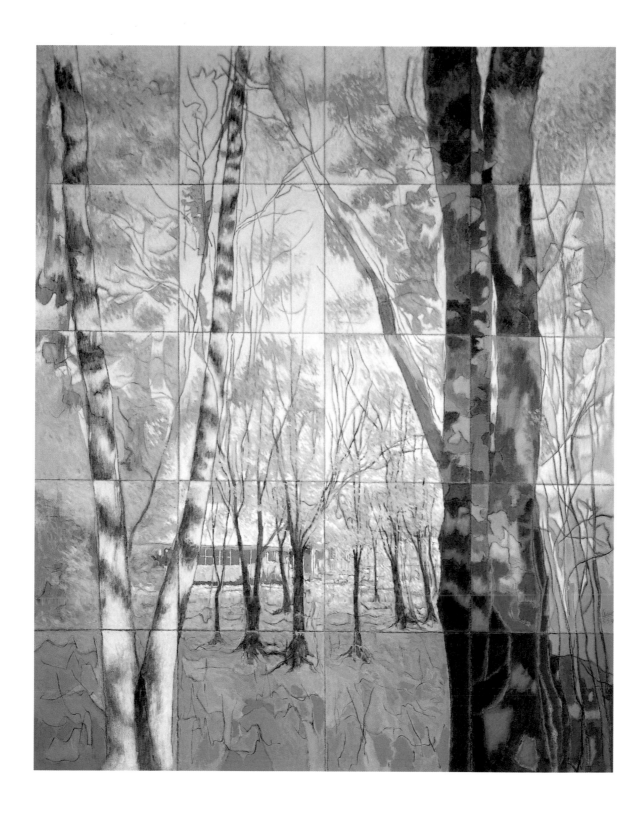

58. VIEW/WAHGOULY I, 1998 Mixed media on canvas, 48 x 26 inches
Collection of Dr. and Mrs. Harry Greenberg, New Orleans, Louisiana

Works in the Exhibition

1. STILL LIFE, 1940
Oil on canvas, 35 x 24 inches
Collection of the Artist, New Orleans,
Louisiana

2. "HOW MEN THEIR
BROTHERS MAIM," 1942
Oil on canvas, 35 x 26 inches
Collection of Edwin Lupberger,
New Orleans, Louisiana

3. SEE UNGEHEUER, 1944
Oil on panel, 24 x 36 inches
Collection of Herbert Halpern and
Jacqueline Bishop, New Orleans,
Louisiana

4. SWAMP FIRE,1947
Watercolor, gouache on paper,
18 x 24 inches
Collection of the Artist, New Orleans,
Louisiana

5. CONSEQUENCES OF
MORNING, 1947
Watercolor, gouache on oatmeal
paper, 18 x 24 inches
Collection of Mari Newman Colie
and Stuart Colie, Ocean Springs,
Mississippi

6. KNEELING NUDE, 1949
Oil on canvas, 40 x 30 inches
Collection of the Artist, New Orleans,
Louisiana

7. TWO FIGURES—MACBETH,
1949
Oil on canvas, 60 x 40^{1}/$_{2}$ inches
New Orleans Museum of Art,
Gift of David Clemmer. 97.822

8. TWO NUDES IN A
LANDSCAPE, 1949
Oil on canvas, 50 x 34 inches
Collection of the Artist, New Orleans,
Louisiana

9. NOON VISIT, 1950
Oil on canvas, 38 x 21 inches
Collection of the Artist, New Orleans,
Louisiana

10. PORTRAIT—CHARLES
BOWEN, 1950
Oil on canvas, 40 x 24 inches
Collection of Mr. and Mrs. Charles
Bowen, Stamford, Connecticut

11. NUDE WITH STILL LIFE, 1951
Oil on canvas, 36 x 48 inches
Collection of the Artist, New Orleans,
Louisiana

12. WINDSWEPT, 1952
Casein on paper, 20 x 26 inches
Collection of the Artist, New Orleans,
Louisiana

13 FLORAL/VERTICAL, 1950s
Oil on board, 24 x 32 inches
Collection of the Artist, New Orleans,
Louisiana

14. BLUE VASE, 1955
Oil on canvas, 42 x 37 inches
Collection of the New Orleans
Museum of Art, Gift of Judith and
Robert Stein. 96.239

15. MARCH, 1962
Oil on unprimed linen,
54^{1}/$_{4}$ x 56 inches
Collection of Mrs. F. Monroe
Labouisse Jr., New Orleans, Louisiana

16. VERTICAL VIEW, 1959
Charcoal, oil on canvas,
60 x 24 inches
Collection of the Artist, New Orleans,
Louisiana

17. SALEM SYMBOL, 1966
Oil on panel, 48 x 48 inches
Collection of Mr. and Mrs. Victor
Bruno, New Orleans, Louisiana

18. PORTRAIT—WING
MACDONALD (FLORENCE MAY
MACDONALD), 1961-62
Oil on canvas, 48 x 36 inches
Collection of Florence and John
Boogaerts, Cos Cob, Connecticut

19. ALMEDIA, 1962
Collage, oil on panel, 72 x 48 inches
Collection of David Clemmer,
Santa Fe, New Mexico

20. NARANJA, 1963
Oil on board, 48 x 48 inches
Collection of Gary and William A.
Baker, New Orleans, Louisiana

21. PORTRAIT—LIN EMERY AND
SHIRLEY BRASELMAN, 1967-68
Oil on canvas, 60 x 50 inches
Collection of Lin Emery and Shirley
Braselman, New Orleans, Louisiana

22. TOPOGRAPHIA I—COSMAS
I, 1969-70
Mixed media on canvas,
48 x 48 inches
Private Collection, Washington, D. C.

23. TOPOGRAPHIA II—
ATITLAN, 1969
Mixed media on canvas,
48 x 48 inches
*Collection of the School of
Architecture, Tulane University,
New Orleans, Louisiana*

24. TOPOGRAPHIA III—
GUATEMALA, 1969-70
Mixed media on canvas, 48 x 48 inches
*Collection of the Honorable and Mrs.
Martin L. C. Feldman, New Orleans,
Louisiana*

25. TOPOGRAPHIA IV—
COSMAS II, 1970
Oil on canvas, 48 x 48 inches
*Collection of the New Orleans
Museum of Art, Gift of Jonathan
Clemmer. 97.823*

26. TOPOGRAPHIA V—
CAPRICORN, 1973
Oil on canvas, 60 x 40 inches
*Collection of Jonathan Clemmer,
New York, New York*

27. TOPOGRAPHIA VI—
LUNA, 1969
Polymer/oil on canvas, 48 x 48 inches
*Collection of the Artist, New Orleans,
Louisiana*

28. FLORAL—CIRCLES II, 1974
Oil on canvas, 60 x 24 inches
*Collection of Margery and Charles
Stich, New Orleans, Louisiana*

29. WAHGOULY PORTAL, 1977
Oil on canvas, 76 x 27¹/4 inches
*Collection of BlueCross and
BlueShield of Louisiana, Baton Rouge,
Louisiana*

30. LANDSCAPE, 1977
Watercolor, gouache, collage on
oatmeal paper, 18 x 24 inches
*Collection of David Clemmer,
Santa Fe, New Mexico*

31. PORTAL—FESTIVE, 1979
Watercolor, gouache on oatmeal
paper, 18 x 24 inches
*Collection of Mrs. Edmund McIlhenny,
New Orleans, Louisiana*

32. PORTAL—ITEA, 1978
Oil on canvas, 30 x 30 inches
*Collection of the New Orleans
Museum of Art, Muriel Bultman
Francis Collection. 86.171*

33. PORTAL—JUDEAN, 1977
Oil on panel, 60 x 48 inches
*Collection of Mr. and Mrs. William A.
Porteous, New Orleans, Louisiana*

34. CIRCLE—SHIELDS, 1987
Oil on canvas, 36 x 36 inches
*Collection of Lloyd N. Shields,
New Orleans, Louisiana*

35. PORTAL—VIEW, 1980
Oil on canvas, 48 x 48 inches
*Collection of Beverly and Lester
Wainer, Metairie, Louisiana*

36. JOURNEY TO TORCELLO, 1981
Mixed media on Strathmore,
36¹/2 x 26¹/2 inches
*Collection of Julian and Peggy Good,
New Orleans, Louisiana*

37. JOURNEY TO MURANO, 1982
Mixed media on Strathmore,
34 x 27 inches
*Collection of Julian and Peggy Good,
New Orleans, Louisiana*

38. FLORAL IV, 1981
Oil on canvas, 61 x 27 inches
*Collection of Bobby and Karen Major,
New Orleans, Louisiana*

39. MURANO I, 1982
Oil on canvas, 26 x 24 inches
Private Collection, Houston, Texas

40. THE SEASONS, 1982
Watercolor on Bristol board,
18¹/2 x 13¹/2 inches
*Collection of Dr. and Mrs. Eamon
Kelly, New Orleans, Louisiana*

41. PLUMED, 1985
Mixed media on papel de amate,
17 x 24¹/2 inches
*Collection of the Artist, New Orleans,
Louisiana*

42. EXALTATION, 1987
Mixed media on papel de amate,
40 x 32¹/2 inches
*Collection of Dr. Joseph D. Kirn,
New Orleans, Louisiana*

43. VAPIOS, 1987
Mixed media on papel de amate,
7³/4 x 23³/4 inches
*Collection of Bobby and Karen Major,
New Orleans, Louisiana*

44. SCULPTURE, 1986
Bronze, nickel silver on monel,
120 x 30 inches
*Collection of Rick and Martha
Barnett, Tallahassee, Florida*

45. TANGIPAHOA, 1987
Oil on canvas, 44 x 22 inches
*Collection of the Artist, New Orleans,
Louisiana*

46. SAN G. I, 1991
Oil on canvas, 48 x 24 inches
*Collection of Dr. and Mrs. Charles
Smith III, New Orleans, Louisiana*

47. SAN G. II, 1993
Oil on canvas, 72 x 36 inches
*Collection of the Artist, New Orleans,
Louisiana*

48. CORTONA/CREPUSCOLO,
1992
Mixed media on canvas,
54 x 60 inches
*Collection of the Artist, New Orleans,
Louisiana*

49. TRILOGY XIV, 1994
Oil crayon on Strathmore,
30 x 26 inches
*Collection of the Artist, New Orleans,
Louisiana*

50. TRILOGY XVI, 1994
Oil crayon on Strathmore,
30 x 26 inches
*Collection of the Artist, New Orleans,
Louisiana*

51. ROAD TO VOUKARI/KEA,
1992
Oil on canvas, 30 x 26 inches
*Collection of Maestro James Paul,
Baton Rouge, Louisiana*

52. TEMPLE OF POSEIDON I,
1992
Mixed media on canvas,
50 x 60 inches
*Collection of the Artist, New Orleans,
Louisiana*

53. TRIUNITY I, 1995
Mixed media on canvas,
56 x 45 inches
Collection of the New Orleans Museum
of Art, Museum Purchase. 97.126

54. TRIUNITY V, 1997-99
Mixed media on canvas,
60 x 50 inches
Collection of the Artist, New Orleans,
Louisiana

55. FROM THE COUNTRY
HOUSE I, 1995
Oil on canvas, 11 x 22 inches
Collection of the Gerald Peters
Gallery, Santa Fe, New Mexico

56 BIRCHES/DUO, 1996
Oil on board, 12 x 24 inches
Collection of the Artist, New Orleans,
Louisiana

57. THROUGH THE WOODS, 1997
Mixed media on canvas,
60 x 48 inches
Collection of Burton Jablin,
Knoxville, Tennessee

58. VIEW/WAHGOULY I, 1998
Mixed media on canvas,
48 x 26 inches
Collection of Dr. and Mrs. Harry
Greenberg, New Orleans, Louisiana

**18 DRAWINGS FROM THE
COLLECTION OF THE ARTIST**

Not illustrated in catalogue

59. "HOW MEN THEIR
BROTHERS MAIM," 1942
Sepia ink on paper,
9$^{1}/_{2}$ x 6 inches

60. SEE UNGEHEUER, 1944
Sepia ink on paper,
6 x 8$^{3}/_{4}$ inches

61. VIEW FROM THE
BARRACKS, 1944
Ink on paper,
10$^{1}/_{2}$ x 9$^{1}/_{2}$ inches

62. BARRACKS—
FT. LIVINGSTON, 1944
Ink on paper,
10$^{1}/_{2}$ x 7$^{1}/_{4}$ inches

63. MAIL CALL, 1944
Ink on paper,
11$^{1}/_{4}$ x 9$^{1}/_{4}$ inches

64. BARRACKS LEADER, 1944
Pencil on paper,
13$^{1}/_{4}$ x 9$^{1}/_{2}$ inches (sight)

65. SOLITAIRE, 1944
Ink on grey paper,
7$^{1}/_{4}$ x 10$^{1}/_{2}$ inches

66. DON QUIXOTE, 1947
Ink on paper,
13$^{3}/_{4}$ x 9$^{3}/_{4}$ inches (sight)

67. HARLEQUIN, 1947
Ink, ash on paper,
9 x 6$^{1}/_{2}$ inches

68. NUDE WITH STILL LIFE,
1949
Ink on paper,
6 x 7$^{1}/_{4}$ inches (sight)

69. SEATED NUDE, 1951
Ink on paper,
9$^{3}/_{4}$ x 7 inches (sight)

70. LEAR, 1951
Ink on paper,
12$^{1}/_{2}$ x 7 inches (sight)

71. NUDE—REAR, 1952
Ink on paper,
10 x 13 inches

72. NUDE—BACK, 1952
Ink on paper,
13$^{1}/_{4}$ x 13$^{1}/_{4}$ inches (sight)

73. DRAWING/DAVID, 1969
Pencil on Strathmore,
9$^{1}/_{4}$ x 9$^{1}/_{2}$ inches (sight)

74. STUDY—CAPRICORN/
TOPOGRAPHIA, 1972
Ink on paper,
10$^{1}/_{2}$ x 7$^{3}/_{4}$ inches (sight)

75. IL CAPANNONE,
CORTONA, 1987
Ink on paper,
9$^{1}/_{4}$ x 13$^{1}/_{4}$ inches (sight)

76. LANDSCAPE—WAHGOULY,
1993
Colored pencil on Bristol Board,
12 x 10 inches (sight)

Chronology

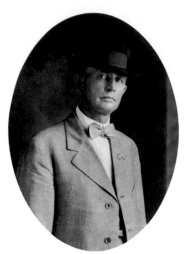

John Franklin Clemmer Sr.

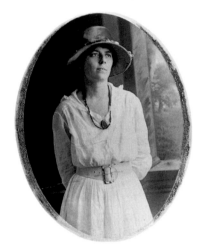

Marie Landry Clemmer

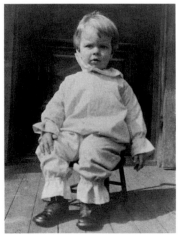

John Clemmer in Mardi Gras costume, New Orleans, circa 1924.

1921 Born on July 22, 1921, near Donaldsonville, Louisiana, the first child of John Franklin Clemmer (b. 1874) and Marie Landry Clemmer (b. 1884)

1928 Leaves the Louisiana countryside for New Orleans with the Clemmer family, moving into a house in the Irish Channel neighborhood.

1937 Marie Clemmer dies on November 26 from injuries suffered in a gas explosion at the family home on Magazine Street.

1939 Graduates from Fortier High School. Begins studies at the New Orleans Art School, continuing until 1942. Early works on canvas and paper executed through the 1940s are primarily figurative, but evidence Cubism-influenced abstraction.

1941 John Franklin Clemmer dies from heart disease on May 10. John Clemmer marries Marjorie Fischer on June 14.

1942 A daughter, Trina Marie Clemmer, is born on September 19.

1944 Inducted into the US Army, January 27.

1945 A son, Erik Patrick Clemmer, is born on March 17.

Awarded First Prize in the Annual Exhibition of the Arts and Crafts Club of New Orleans—first recognition as a professional artist.

1946 Honorably discharged from the US Air Force with the rank of corporal on January 19. Returns to New Orleans and assumes the jobs of Executive Secretary of the Arts and Crafts Club of New Orleans and Director of the New Orleans Art School.

1947 Dorothy (Dottie) Iker and her first husband arrive in New Orleans and enroll in night drawing classes at the New Orleans Art School with John Clemmer as instructor.

Divorce from Marjorie Fischer is finalized in June. Marries Litza Scoville on October 7.

1948 Solo exhibition at Arts and Crafts Club of New Orleans.

1949 Solo exhibition at Arts and Crafts Club of New Orleans.

Executes first public commission for International Trade Mart, New Orleans.

1951 Accepts position as instructor of Drawing, Painting, and Basic Design in the Tulane School of Architecture, and as Instructor in Art Fundamentals in the University College. Paints primarily in a figurative mode, with emphasis on nudes and still lifes.

1953 Divorce from Litza Scoville is finalized in March.

Converts to Judaism on December 11 and marries Dottie Iker on December 19.

Maintains studio on Conti Street in French Quarter.

1955 Purchases a house at 830 Foucher Street near the Irish Channel. Moves studio from French Quarter to small building on Foucher Street property.

Spends summer vacation at Iker family cottage in Sheboygan, Wisconsin.

Solo exhibition at 331 Gallery, New Orleans.

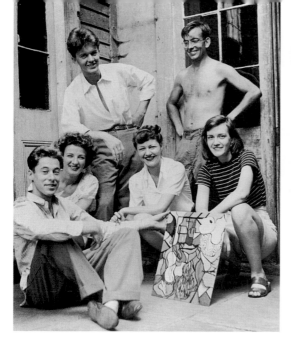

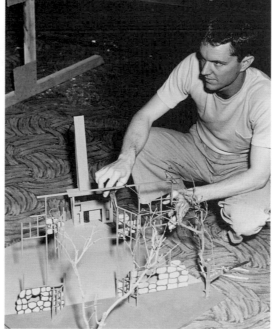

1956 First trip to Europe, visiting Turkey, Greece, Italy, and Great Britain.

Solo exhibition at School of Architecture, Tulane University, New Orleans.

1957 A son, Jonathan Charles Clemmer, is born on September 27.

1958 Paints first Wisconsin landscape, *Franklin, WI,* and begins to experiment with collage.

1959 Promoted to Assistant Professor at Tulane School of Architecture.

A son, David John Clemmer, is born on October 2.

1960 Solo exhibition at School of Architecture, Tulane University, New Orleans.

Solo exhibition at Orleans Gallery, New Orleans.

Begins working in sand sculpture medium.

1962 Awarded travel grant from the School of Architecture, Tulane University, to visit schools of architecture in Colombia. Begins major series of abstract paintings and collages, most on panel and many utilizing a paint roller, based on South American experience—through 1970.

Solo exhibition at Orleans Gallery, New Orleans.

1966 Promoted to Associate Professor, Tulane School of Architecture.

Travels to Guatemala and Yucatan Peninsula during summer recess.

1967 Receives study grant from School of Architecture, Tulane University, to attend summer seminar at Massachusetts Institute of Technology, "Form and Color," with instructors Gyorgy Kepes, Richard Filipowski, and Robert Preusser.

1968 Travels to Greece, Italy, and Switzerland during summer recess.

Solo exhibition at Clemmer residence on Foucher Street.

1969 Begins *Topographia* series of large geometric abstractions, which continues until 1973.

Rents studio on Magazine Street for making sculpture—through 1975. Begins work on first of several sculptural fountain commissions.

1970 Begins working with oxy-acetylene welding and investigating a variety of sculptural media, including bronze, lucite, and wood, often in combination with sand sculpture.

Solo exhibition at Clemmer residence on Foucher Street.

Clemmer residence (1955-1994),
Foucher Street, New Orleans.

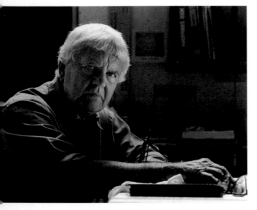

Artist in Sheboygan, WI, studio, 1997.

1971 Solo exhibition at Clemmer residence on Foucher Street.

Undertakes first in series of sculptural commissions on Jewish religious themes.

1972 Solo exhibition at Louisiana State University, Alexandria, Louisiana.

Solo exhibition at Jewish Community Center, New Orleans.

1973 Takes sabbatical leave. During summer Clemmer family travels to Europe, visiting Greece, Italy, Spain, Portugal, England, and Scotland. Abstract paintings during the 1970s reflect European and Central American travels.

1974 Promoted to full Professor, Tulane School of Architecture.

Solo exhibition at Clemmer residence on Foucher Street.

1975 Purchases and remodels double shotgun house on Laurel Street adjoining Foucher Street property as a combined painting and sculpture studio.

1977 Begins *Portal* series of paintings, continuing to 1979.

1978 Appointed Chairman, Department of Art, Newcomb College, Tulane University.

Discovers *papel de amate* while on trip to Mexico. Begins series of paintings utilizing this medium, continuing into 1980s.

Solo exhibition at Clemmer residence on Foucher Street.

1981 First recipient of Maxine and Ford Graham Chair in Fine Art, Tulane University. Takes sabbatical leave, traveling to Italy. Builds studio in Sheboygan, Wisconsin, next to family summer cottage.

1986 Retires from Tulane University. Elected Professor Emeritus of Art, Newcomb College, Tulane University. Begins spending summer and fall months in Wisconsin.

1988 Solo exhibition at Carmen Llewellyn Gallery, New Orleans.

1989 Travels in Russia and Sweden. Thereafter, travel to Europe at one to two year intervals, most frequently to Italy and Greece.

1991 Begins continuing series of landscape drawings and paintings of Greece, Italy, and Wisconsin, most divided into three vertical registers. First use of colored pencil for drawings.

1993 Solo exhibition at President's Residence, Tulane University.

Solo exhibition at Academy Gallery, New Orleans.

1994 Begins *Triunity* series of large abstractions and related *Trilogy* series of oil crayon on paper.

Sells house on Foucher Street, but retains studio on Laurel Street.

1995 Begins the continuing series of *Country House* landscapes named after a resort in Door County, Wisconsin.

1997 *Country House X* is first of a continuing series of drawings and paintings divided into square or rectangular fields.

1999 Retrospective exhibition at New Orleans Museum of Art.

Solo exhibition at the Academy Gallery, New Orleans.

American Artist - Individual
(oversize)

American Artist - Individual
(oversize)